IMAGES
of America

HESSEL, CEDARVILLE,
AND THE
LES CHENEAUX ISLANDS

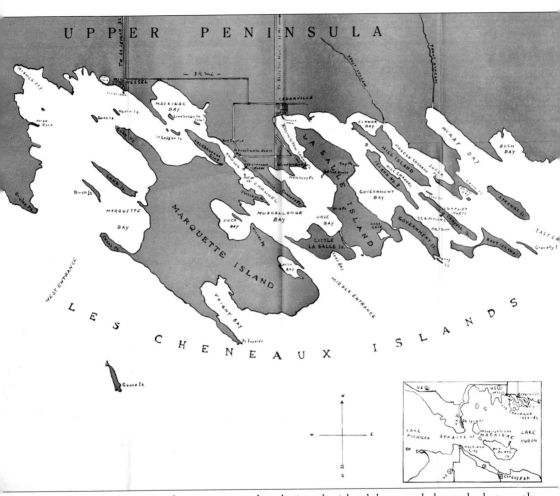

This is an early twentieth century map that depicts the island, bays, and channels that are the Les Cheneaux Island area.

ON THE COVER: Small sailboats were a common sight on the waters of the Les Cheneaux area during the late 19th and early 20th centuries. Sailboats, as the one depicted in this Andrew W. Tanner photograph, were popular means of transportation for residents of the islands and mainland to commute to homes and businesses in the area. Sailboats were also used for fishing and leisure activities. This is the Tanner family in the *Helen T* in 1897. Andrew W. Tanner was a popular photographer who spent his summers on Coryell Island. (Courtesy of Les Cheneaux Historical Association.)

IMAGES
of America

HESSEL, CEDARVILLE, AND THE LES CHENEAUX ISLANDS

Deborah I. Gouin for the
Les Cheneaux Historical Association

ARCADIA
PUBLISHING

Published by Arcadia Publishing
Charleston, South Carolina

Printed in the United States of America

Library of Congress Control Number: 2011928978

For all general information, please contact Arcadia Publishing:
Telephone 843-853-2070
Fax 843-853-0044
E-mail sales@arcadiapublishing.com
For customer service and orders:
Toll-Free 1-888-313-2665

Visit us on the Internet at www.arcadiapublishing.com

*To my parents, Elizabeth and James Gouin, who always
encouraged me, and to Meredith and Steve Sheridan,
who introduced me to the Les Cheneaux Islands*

CONTENTS

ACKNOWLEDGMENTS

The Les Cheneaux Historical Association was founded in 1967 to preserve the history of the Les Cheneaux area. The Association oversees two museums: the Les Cheneaux Historical Museum, which interprets the history of the communities of Cedarville and Hessel, and the Maritime Museum, which tells the story of boating in the area. The Association is the sponsor of the Antique Wooden Boat Show and Festival of Arts.

I would like to thank the Les Cheneaux Historical Association for allowing me to use their archives. Their dedication to the preservation of the local history made this project possible. I would like to thank Richard B. (R.B.) Smith who was the President of the Association at the time I began this project. Mr. Smith shared his extensive knowledge of the Les Cheneaux area with me and took me to Marquette Island in his boat to allow me to get a better perspective of the island and the Les Cheneaux Club house. Mr. Smith's family has lived in the Les Cheneaux community since the late nineteenth century. He is the fourth generation of his family to live in the Les Cheneaux area.

Unless otherwise noted, all images appear courtesy of the Les Cheneaux Historical Association.

I would like to thank the people of the Les Cheneaux community who are far too numerous to mention here. Everyone's interest, excitement, and encouragement in this project have kept me motivated in the creation of this book.

I also want to thank my editors at Arcadia Publishing for their expert guidance (when requested). Their help and patience with my technical issues was appreciated. Finally, to my husband, Wilbert Hines III, thank you for your love and patience on this project and with everything I do.

INTRODUCTION

The Les Cheneaux area has a long history as the home of both the Ottawa (Ojibwa) and Chippewa (Anishinabe) tribes. They hunted the mainland and islands and fished the shores of Lake Huron. The French learned of the area in the 17th century and became partners in the fur trade with the natives and the English during the 18th century. The fur trade in the area flourished until the early 19th century when fur-bearing animals became sparse and the Michigan territory was preparing for statehood.

The communities of Hessel, Cedarville, and the Les Cheneaux Islands were developed much later than many Michigan communities in the area. The land had to be acquired from the natives by the Washington Treaty of 1836 and of 1855. The treaty of 1855 negotiated for the tribes to take ownership of lands they selected in the eastern Upper Peninsula area. Granting land patents to the Native Americans took longer than expected and was not complete until the summer of 1871. The 1855 treaty prohibited the land from being sold for 10 years after the patents were granted to protect the Native Americans' interest in their property from land speculators. Hence, development of the area was delayed until early 1881. By this time, the neighboring communities of St. Ignace and Mackinac were already well-established resort areas. The Les Cheneaux community quickly became a summer resort area as well.

While speculators had an eye on the Les Cheneaux area for development into a resort community, profits were being made from the timbering of the land, which was necessary before the construction of resorts and homes could begin. Speculators bought land to establish hotels and to sell lots for summer homes. This strategy was employed by many of the early hotel owners. They realized the popularity of summering in the Straits of Mackinac and on the islands. Clearly, Mackinac Island was not big enough to satisfy the needs of all the travelers, and other places were sought for leisure time.

The most successful of the land development businesses in the Les Cheneaux area was the Les Cheneaux Club. Four Bay City businessmen saw an opportunity to develop an area of Marquette Island. They formed the Les Cheneaux Islands Resort Association under the Michigan Public Act (MPA) No. 122 of 1877. This act allowed groups of people to establish summer-home colonies under favorable conditions. The State of Michigan encouraged this development with the use of the public acts, because it had large parcels of land that had escheated back to the state from overdue taxes. Some of this was cutover land from the lumbering industry in the Lower Peninsula or from the Native Americans who could not pay the taxes. Either way, the state needed to encourage development of the land to increase tax revenue. The MPA No. 122 of 1877 was purposely written to establish recreational associations that would promote sporting activities, such as fishing, hunting, yachting, and other sports. This fit the needs of the Les Cheneaux Island Resort Association, because it sought to attract people wanting space for leisure-time activities.

The Les Cheneaux Club built a clubhouse and hotel for prospective buyers and club members. It operated as a full-service hotel for club members and their guests. This gave prospective buyers

and those building homes a place to stay. This worked very well for the Les Cheneaux Club. In 1901, the club strengthened its association by reorganizing under the Summer Homes Act of 1889. This allowed the association to purchase, own, and improve the holdings for the benefit of the association. Other land schemes did not take advantage of these liberal public acts.

The early 20th century saw the rise of many resorts in the Les Cheneaux region. Hotels were very popular, and there were 14 hotels throughout the area. They were built out of wood and depended on gas for lighting. Unfortunately, fire was the fate of most of them. The few that remained by 1960 were razed, because of the high cost of insurance and the risk of fire. Building hotels on the islands worked well when steamships operated in the area. Guests and their luggage were dropped off at the dock of each hotel. Supplies to run the business were delivered to the hotels by the local general stores. Mostly, the upper-middle class and the wealthy took extended summer vacations to avoid the heat of the city. After World War II, vacation habits changed in America.

The rise of the middle class after World War II, the benefits that unions won for workers, and the change in travel meant more people could take summer vacations, although how people vacationed changed. Most workers had one or two weeks of summer vacation time. The days of hotel guests spending four to six weeks at a resort were mostly gone. Trains and steamships stopped serving the area, and most people traveled by car to their vacation destinations. Before the completion of the Mackinac Bridge, car ferries transported passengers across the Straits of Mackinac with their vehicles. Once vacationers arrived in the Upper Peninsula, they drove to resorts that specialized in small housekeeping cabins. Hotel dining rooms were not needed, because visitors shopped for their own meals at stores or chose from a variety of restaurants in the area. Gone were the days of hotels becoming small communities where guests socialized during long evenings of parlor games. Vacationers now spent time with their nuclear family in cabins that were built to accommodate the family. Locals rose to this new vacation model, and complexes with small weekly rental cabins were built. The fishing, swimming, and cool nights, along with the amenities that brought the early vacationers to the area, still attracted modern vacationing families. Recreation was still the dominant business in the Les Cheneaux Islands.

Storekeeping was always necessary, because those who lived in the area and the visitors had to buy the necessities. Industry, however, was nonexistent. Boat-works businesses were important. The island dwellers and the vacationers needed to keep their boats on the water. While in most areas, a marina or boat-repair place was not common, in the Les Cheneaux region there were several. These businesses have always been important to the area; without them, travel and leisure pastimes would suffer. They are the backbone of the waterfront communities. It is a tribute to their skill that visitors today enjoy the well-preserved wooden boats cruising the waterways daily. When the wooden boats travel the area, time stands still.

I will discuss the development of the waterfront communities of Hessel and Cedarville. The historic hotels will be revisited, and the islands and channels will be explored. I will take a look at the businesses that have survived the past century, and those that have disappeared with time will be remembered. The Les Cheneaux Islands capture the hearts and minds of all who come, whether for a day or for a lifetime. The area's natural beauty and the friendly people draw visitors back each season by car and yacht; it is the perfect place to spend some leisure time.

One

HESSEL

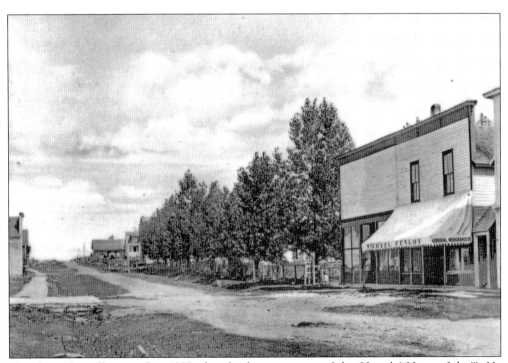

Hessel was formally named in 1888 after the first postmaster, John Hessel ("Honest John"). He owned the local trading post and was known for his fair dealings with other pioneers in town, and the post office was housed in the trading post. Joseph Fenlon clerked for Honest John in his original store, and the Fenlon family liked the mercantile business. In 1891, Joseph and his brother James built this general store.

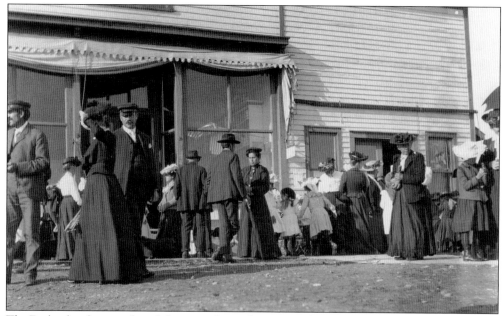

The Fenlon brothers combined the general-store business with a timbering business. They invested in several parcels of property in the Hessel area and timbered the land. The Fenlon store was frequented by both pioneer families and summer residents. In this early-20th-century view of the general store, community residents gather in front of the Fenlon store to visit with each other while on their way shopping.

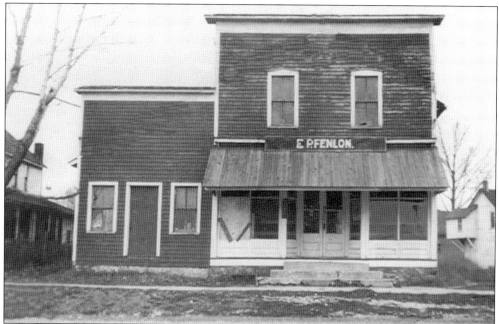

Hessel's business district included the E.P. Fenlon Saloon on Lake Street. The saloon was owned and operated by Edward P. Fenlon. Fenlon sold the saloon to the VFW organization. They used it as a meeting place and social hall. Fire destroyed the building in the early 1950s, and was rebuilt by the VFW. Many years latter they sold the building.

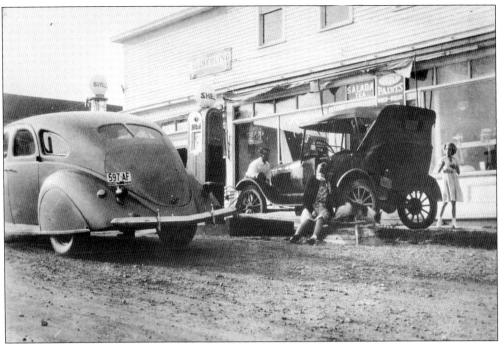

Roads in Hessel were not paved in the early years. This image is in front of the Fenlon store in the 1930s. The store carried a variety of things, including food, dry goods, hardware, and gasoline. The establishment catered to Les Cheneaux Club members, delivering groceries to the club in the afternoon. According to *Ripples from the Breezes*, this service ended in the 1940s.

McFee's was a popular place. It was a long-established tavern and soda fountain, which catered to both the adults, selling beer and wine, and the youth of the area enjoyed sodas and ice cream.

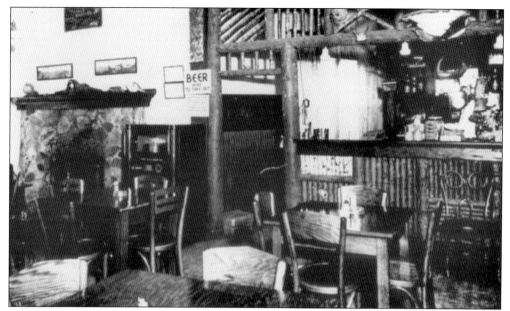

McFee's was one of two local soda-shop establishments that served a local ice cream favorite called a Jersey Mud. Newlyweds Katherine and B. Clark Morse Jr. came back to the area from New York City and introduced this ice cream concoction to the locals.

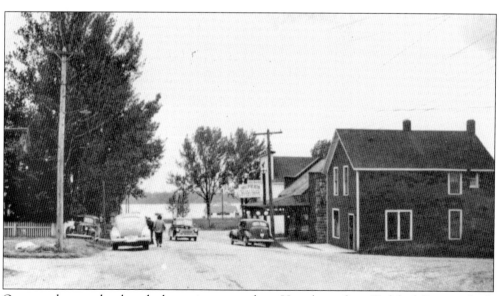

Once roads were developed, the main approach to Hessel was from Pickford Street, which runs south from M-134. This main road ends at Lake Street in front of Hessel Bay Harbor. The development of this artery brought more traffic to local businesses.

This mid-20th-century view of Hessel shows Hessel Grocery. Dorothy and Leonard Rye owned the store for 25 years. The store kept accounts for the locals as well as summer residents. At the end of the season, customers would settle their accounts. Hessel Grocery is still operational and now has a deli with seating for its customers to enjoy a quick meal.

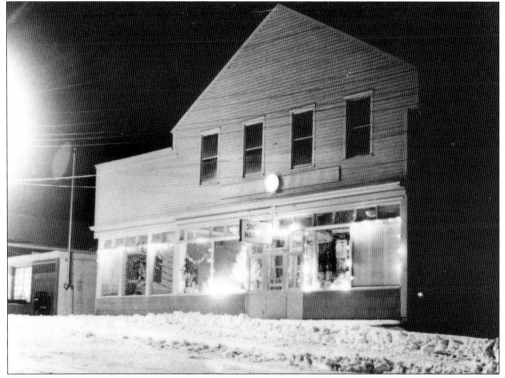

The Fenlon store is ready for the Christmas season with lights and a tree in the front window bringing holiday cheer to its customers. The winter weather had already left a few inches of snow on the ground. Heavy snowfall was challenging to residents in the Upper Peninsula.

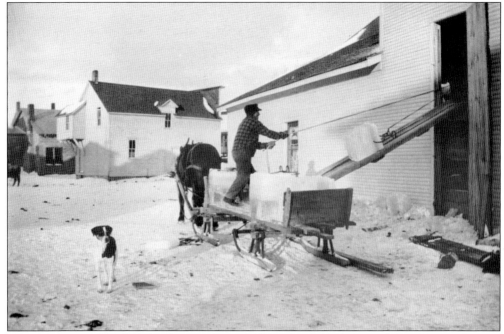

While winter was hard for locals, one thing cold weather brought was plenty of ice to harvest from Hessel Bay. Many people harvested ice and stored it for use throughout the year. In this image, ice is being put up in the Fenlon Store. Fenlon's sold ice throughout the summer to cool customers' ice boxes.

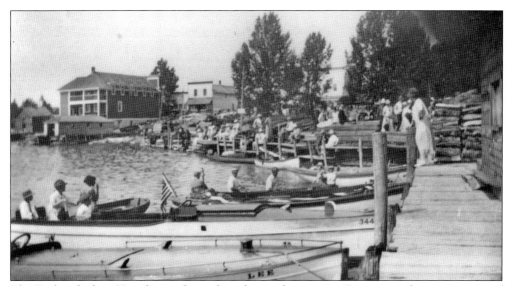

The Fenlon dock in Hessel was a busy place during the summer. Boats were the main means of transportation in the early 20th century, and island residents depended on the dock to gain access to Hessel. A variety of launches and rowboats could be found tied up while their owners would gather on the dock to visit with friends and shop at local businesses. The large building on the shore is Fenlon Hall; it still stands today and is a private residence.

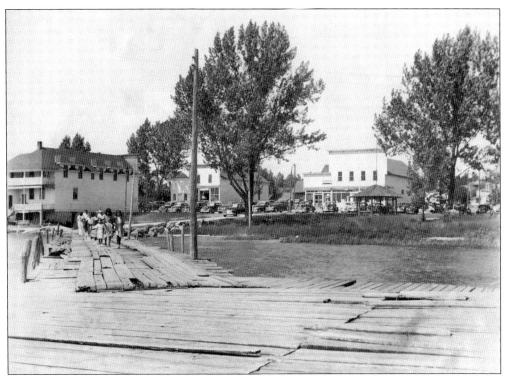

By the mid-20th century, cars became the most popular means of transportation to the Upper Peninsula. Car ferries allowed visitors to bring vehicles across the Straits of Mackinac. While boats were still relied upon to get to and from the islands, steamships no longer operated. The Fenlon dock was still a popular place in Hessel.

The Hessel shoreline provides a beautiful view of Lake Huron and Hessel Bay. This gazebo sat by the shore along the Fenlon dock and provided visitors with a place to picnic in the shade. A different gazebo stands today along the shore of Hessel Harbor.

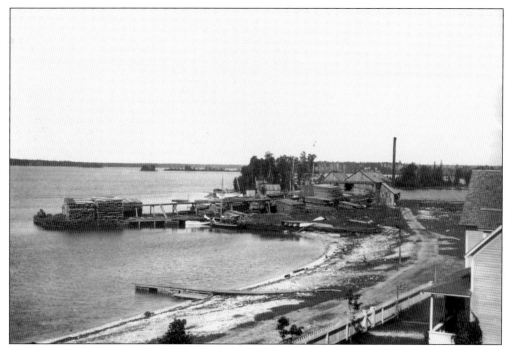

Lumbering was an important industry that employed many people in the area. The Hessel sawmill was built on the shore of the bay and owned by John Hessel. Logs were cut into lumber and then shipped to the Lower Peninsula. By building it on the shore of Lake Huron, Hessel took advantage of the water access to get the lumber to market.

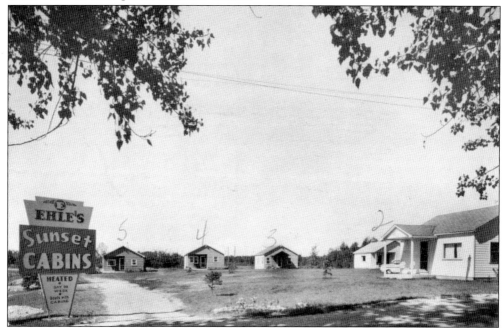

Sunset Cabins resort was built on the site of the sawmill in 1948 by Herman Ehle. The resort consisted of five cabins constructed near the water, which enabled guests to have easy access to the lake for boating and swimming.

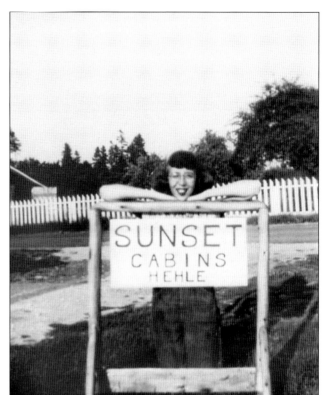

Peggy Ehle stands behind the sign to Sunset Cabins in 1951. They were a simple design and were commonly called light-housekeeping cabins. During the mid-20th century, a typical family rented a cabin up north for a week or two. Sunset Cabins is still in business in the same location, although the cabins have been remodeled since the 1950s.

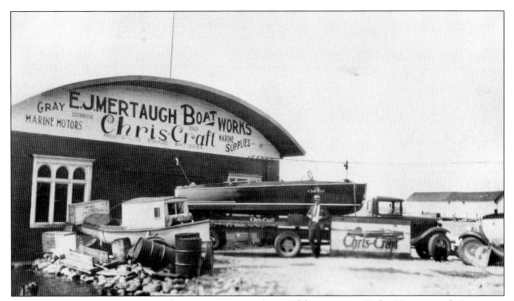

The invention of internal-combustion engines changed boating on Lake Huron and America. Christopher Smith began building powerboats in 1914. By 1924, Chris-Crafts were being made in Algonac, Michigan. In 1925, the first Chris-Craft dealership was opened in Hessel, Michigan, by E.J. Mertaugh. These beautiful mahogany boats became very popular in the Les Cheneaux area. Many boathouses in the islands have at least one Chris-Craft moored there. These boats remain so popular that the Antique Wooden Boat Show is held in Hessel each year.

This mid-20th-century view of Hessel Harbor features the docks at E.J. Mertaugh Boat Works. Harbored at the docks are wooden boats that are still popular today in the Les Cheneaux area. The boathouse and ship store are visible through the trees.

The E.J. Mertaugh Boat Works landmark was a large boathouse that was a popular place for people to stroll through and look at the boats moored there. The boathouse was razed sometime in the 1980s. Tearing down this building accommodated a new gas dock and a new floating dock system. E.J. Mertaugh Boat Works is operated today by Shelly and Brad Koster. The business is not a Chris-Craft dealer, but it does specialize in restoring Chris-Craft and other wooden boats.

The sandy beach at Hessel was, and still is, a popular attraction. It is a great place to relax while watching the children enjoy the cool, clean water of Hessel Bay.

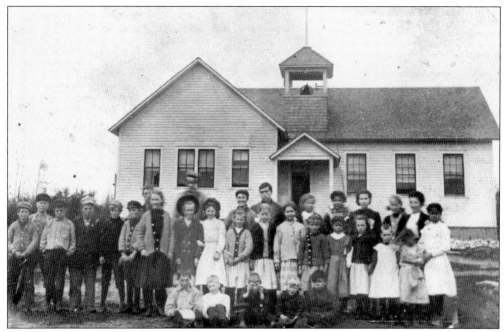

Once summer ended, it was back to school for the local kids. These children are posing outside the Hessel School in 1907. This was a large school building for a small community.

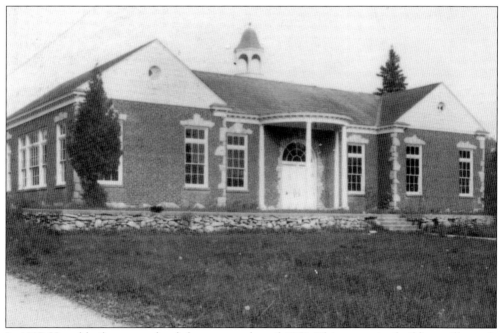

In 1937, Hessel built a new school that operated until 1959. This attractive building still stands in Hessel today and has been converted into a private home.

The Hessel Presbyterian Church was founded in 1901. The building was completed in 1904, constructed on land donated by John Hessel. In 1956, a basement was added by raising the structure off its foundation. It is still used today, and until January 2012 it was part of the De Tour Union Church.

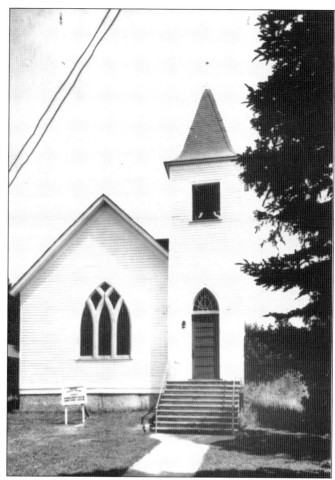

Holy Cross Roman Catholic Church was completed in 1904 and was dedicated in August 1905. It sat not far from where the current Catholic church stands in Hessel. This structure was not the first worship site for Catholics in Hessel. Before it was completed, Mass was held in a log chapel. This church was replaced in 1968 when Our Lady of the Snows held its first Mass on March 27.

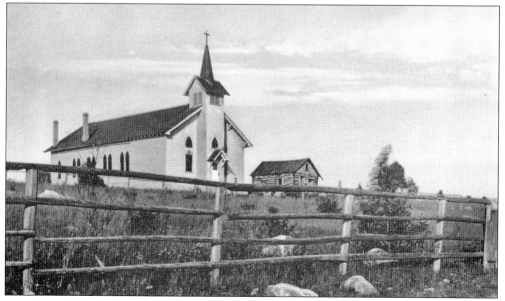

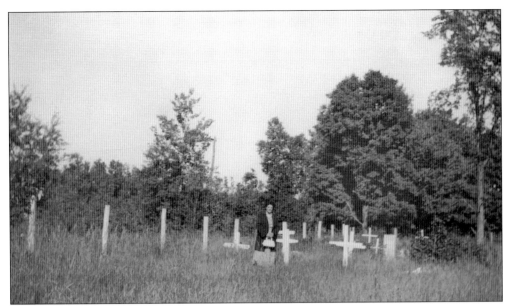

This Native American cemetery is located beside the Catholic church in Hessel. The burial sites still are marked with simple wooden crosses on the graves.

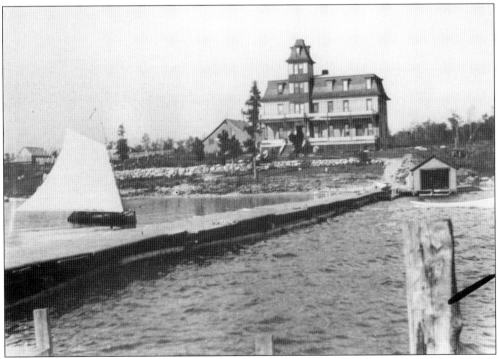

The Bethel home was owned by the Reverend William H. Law. The home was used for multiple purposes: as a hospital and a local meeting hall. Law graciously took in those who needed a place to stay.

Two

CEDARVILLE

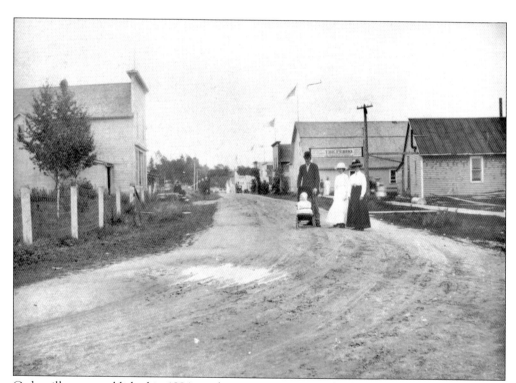

Cedarville was established in 1884 as a logging community. The location on the shores of Lake Huron made it an ideal location for lumbering, because logs were moved by water to sawmills throughout the state. This photograph is of the business district during the early 20th century. An automobile is off in the distance, while a family strolls on the road with a baby carriage.

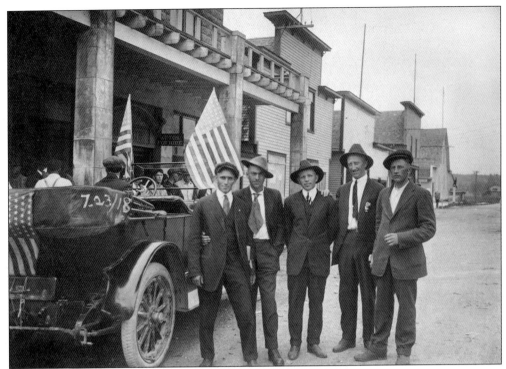

By 1918, the roads had improved in Cedarville. Like all American communities, young men were being sent off to fight in World War I. Local men pose for a photograph in front of Bon Air Store before they leave Cedarville to serve their country in the war.

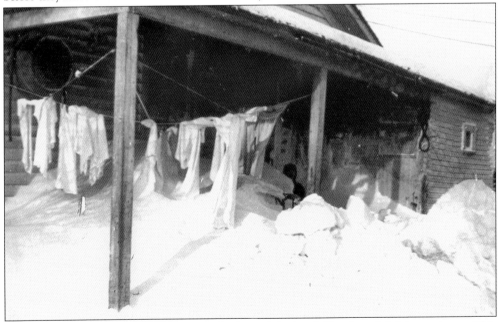

Winters were hard on the local residents who braved the harsh Northern Michigan winters. This cabin is surrounded by snow, and the laundry was hung out to freeze rather than to dry. The cabin's homeowner is barely visible behind the snowdrifts on his porch.

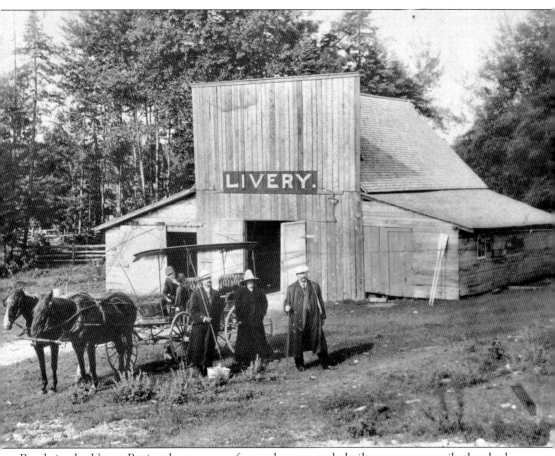

Roads in the Upper Peninsula were very few and were poorly built; most were trails that had been used by Native Americans. While cars did make their way past the Straits of Mackinac to Cedarville, a livery was still a common business past the turn of the 20th century. The ability to rent a horse and buggy was a necessity for travel of any distance in the area and Weston Livery provided this service.

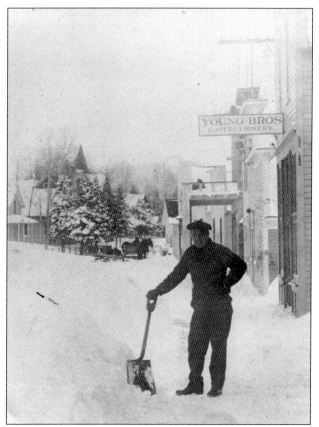

Residents of Cedarville had to contend with huge amounts of snow each winter, yet it did not stop local businessmen or keep the shops closed. The streets were cleared by shovel, but they were not passable by car; only a horse and sleigh could get through. A store owner pauses in front of Young Brother's Confectionery as he clears the walk for customers. This business sold candy and ice cream until it burned in September 1919.

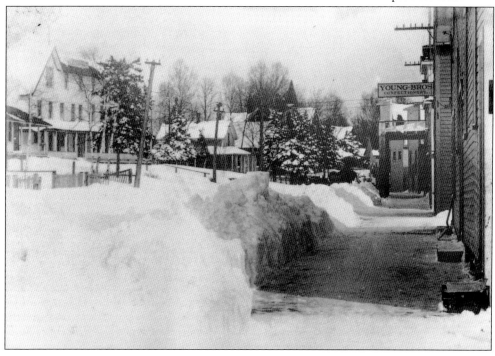

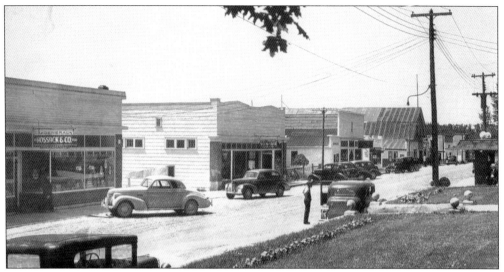

Summer in Cedarville is always very pleasant, and people have gathered here on Hodeck Street to chat. The photograph is of Hossack's Store and the Bon Air in the early 1930s before both stores were destroyed by a fire on January 10, 1938 and rebuilt.

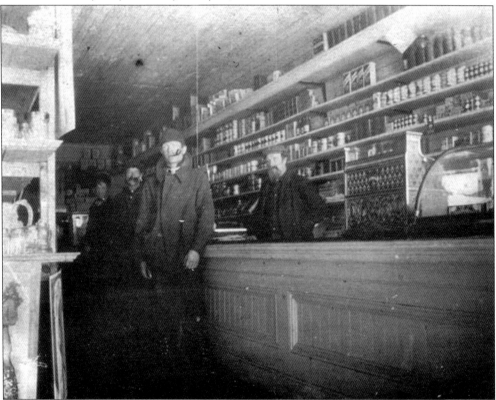

The townspeople would gather in Hossack's Store to pass the time while they shopped for supplies. Like most stores in the early 20th century, goods were kept behind the counter, and the storekeeper would gather the shopping order for the customer. The store was owned by Hossack brothers H.P. and W.D.

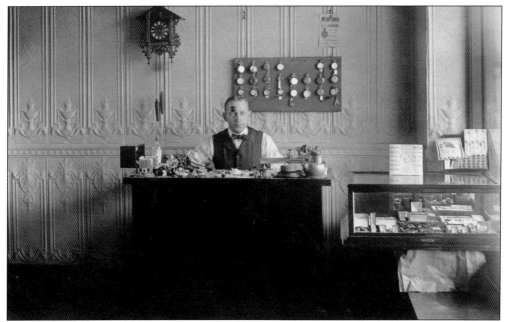

Cedarville had a local jeweler, Harry Townsend. Townsend's store was located on Hodeck Street next to the Young Brothers' Confectionery and Gordie Rudd's Saloon. Townsend is seen here sitting at his workbench repairing watches. Behind him is a board with watches that have been repaired.

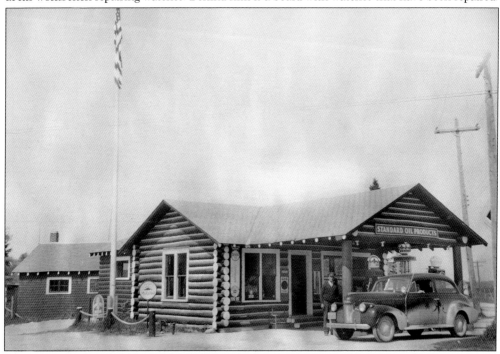

Johnson's gas station was a landmark business for travelers on M-134. Once the log structure was in sight, visitors to the area knew they had reached Cedarville. Arthur Johnson built this Standard station in 1929 and ran it until his retirement in 1955. The log cabin station was moved to Hessel in 1959, and a modern station was built.

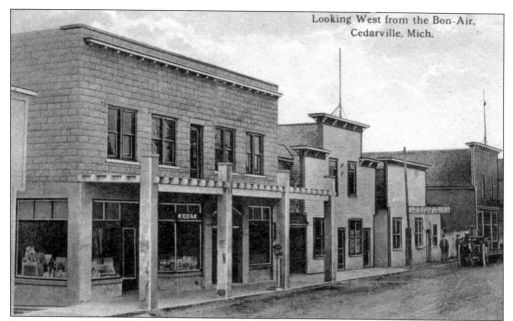

As mentioned earlier, the Bon Air was a popular place in Cedarville. It was owned by George LaFleur and was originally called George's Place. The Bon Air sold ice cream, candy, tobacco, and film products. It had souvenirs and a barbershop, and after Prohibition it also sold liquor. This is what it looked like in 1910.

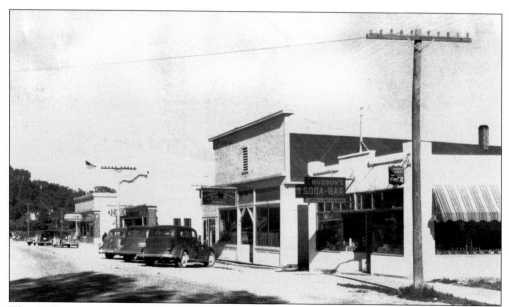

This 1930s view of Hodeck Street shows Bon Air's neighbors the Soda Bar and Snows Café. The café was built by Vance Hodeck in 1922; unfortunately, shortly after constructing it he passed away.

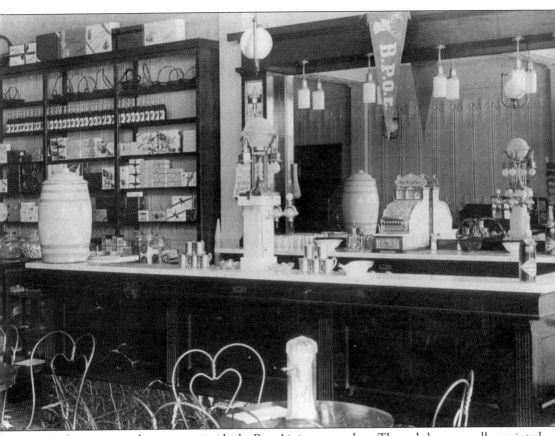

In this image, readers can step inside the Bon Air ice cream shop. The soda bar was well appointed in turn-of-the-century style. The Bon Air was the first establishment in the Les Cheneaux area to serve the Jersey Mud, a concoction of vanilla and chocolate ice cream with chocolate sauce and marshmallow. Between each layer of ice cream, malt powder is sprinkled. All of this is topped with whipped cream. In 1920, Katherine and B. Clark Morse Jr. brought the recipe back from their honeymoon in New York City. This ice cream dish became a popular mainstay and can still be enjoyed at the local ice cream stores today.

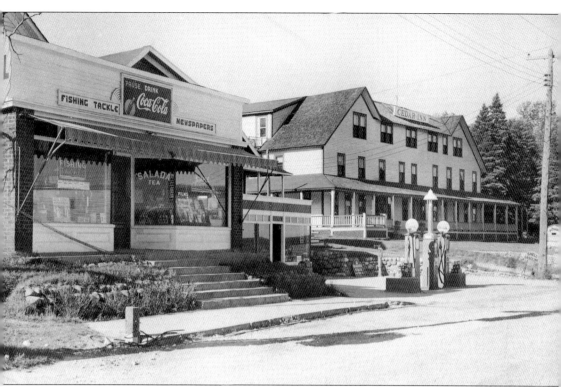

This is a mid-20th-century photograph of the Shell gas station and Hudson's store next to the Cedar Inn on Hodeck Street. It opened in 1929. The market sold convenience items and fishing tackle. It was bought by Harold Pagel, who named it the Superette. Pagel added a drugstore to the business.

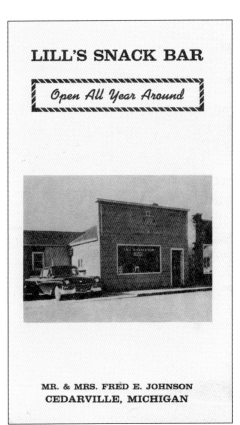

LILL'S SNACK BAR

Open All Year Around

MR. & MRS. FRED E. JOHNSON
CEDARVILLE, MICHIGAN

Lil's Snack Bar was on the waterfront. It was built in 1950 by Lilly and Fred Johnson. They bought the land from Bob Hamel, who had operated a fish market there previously. The Johnsons sold half of the property to Tony Millon, who operated a barbershop next door.

The Hill Top Dairy Bar was located on M-134 across from the Cedarville School. It was a quaint, mid-20th-century Northern Michigan soda fountain. It was finished in knotty pine and featured counter seating and tables. The Hill Top also carried sundries, such as postcards, that were popular with tourists.

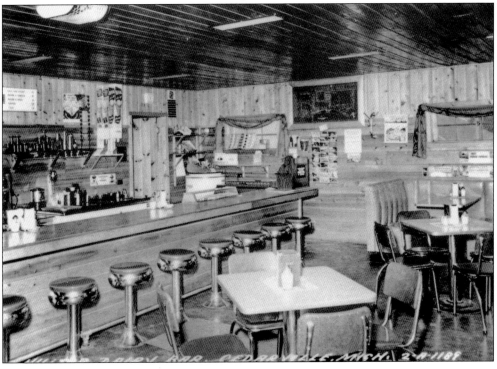

Hodeck Street in Cedarville runs along the shoreline of Cedarville Bay. Both of these photographs show Hodeck Street and the local businesses as they looked from the water. Over time, the dock was built to accommodate the boat traffic that increased through the years. By the 1930s, powerboats became a more common sight on the waters around Cedarville.

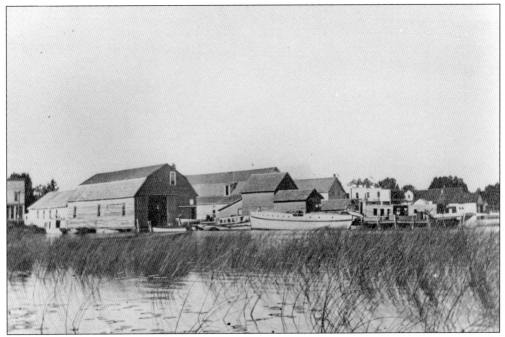

Cedarville depended on the water for travel in its early years, because the roads were nearly nonexistent. This image shows Cedarville's business district in the background with boathouses on the shore. Workboats and rowboats are moored by the dock. The shoreline of Cedarville is a marsh area.

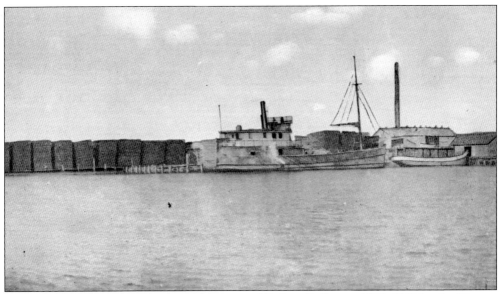

Hossack's Lumber Mill was built on the shore of Cedarville Bay in 1888–1889 by the Haynes Company. The mill was actually constructed over the water to reduce the risk of the mill burning, a common fate for many lumber mills. In 1905, H.P. Hossack purchased the mill, which employed many local people to produce lumber.

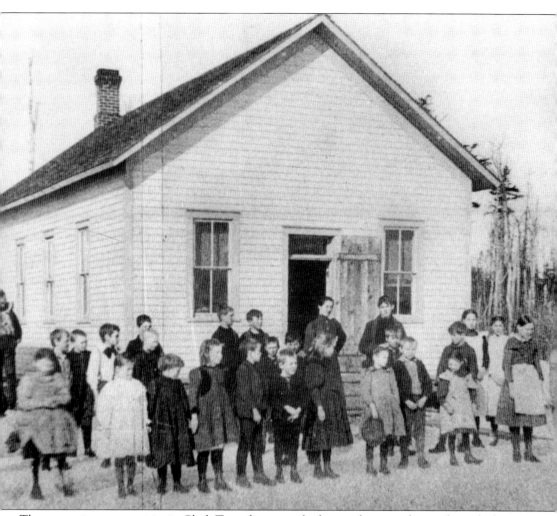

The two major communities in Clark Township are only three miles apart, but in the early days each community supported its own schools. This photograph depicts children in front of one of the first schools in Cedarville. Multiple grades attended this one-room schoolhouse, which dated back to 1893 and was on Meridian Road.

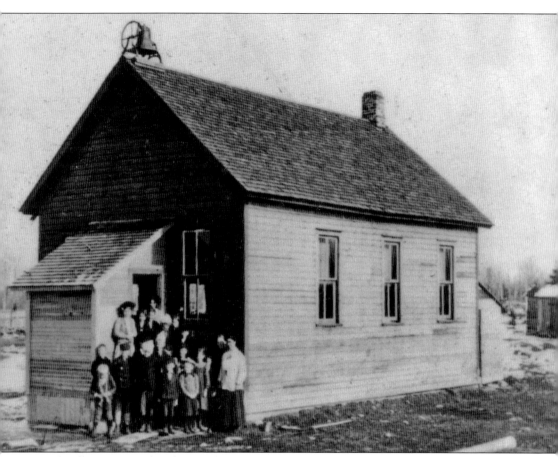

Schoolhouses moved as the population of the community followed the lumbering business. The Linderman School was one of those that popped up to serve the needs of the people living near Blind Line and Linderman Road.

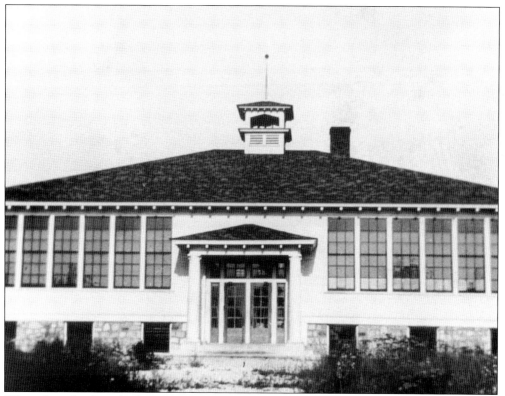

When this school was built in 1923, it was the first to have multiple classrooms. When it opened, it consisted of grades 1 through 10. In 1931, grades 11 and 12 were added, and the first graduation took place in 1932.

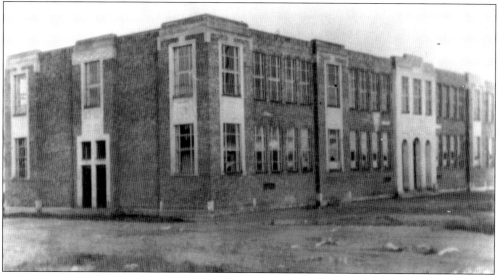

In 1937, the older school was torn down, and the current school pictured here was built. While construction took place, students used the town hall and the Cedar Inn for classrooms. In 1939, the school was completed, and graduation was held that same year. In 1959, a grade school was added to the high school, and the Hessel School was closed. Students still use this school today.

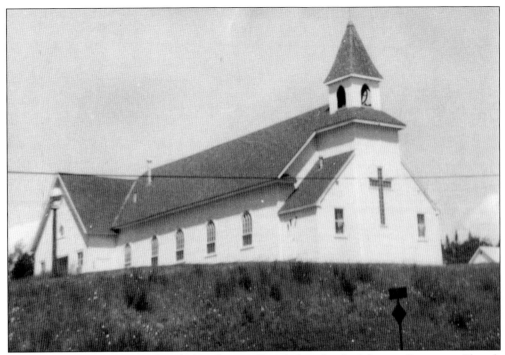

In 1954, the congregation of Bethel Lutheran Church bought the Mission Covenant Church and remodeled it to suit the needs of their community. A parsonage was added for their minister. Their previous church was moved to this location for use as a social hall. This church is still an active Lutheran community today.

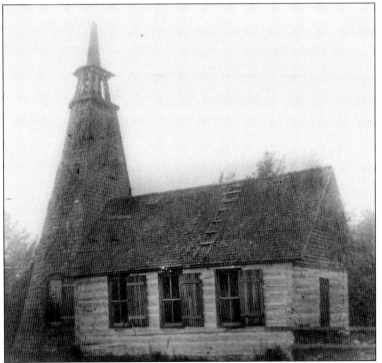

The Dolzen Church built in 1892 and served the community for many years. In 1922 it was razed. The Lutherans bought the land and this is now the site of the Bethel Lutheran Church. It is located on M-129 north of Cedarville.

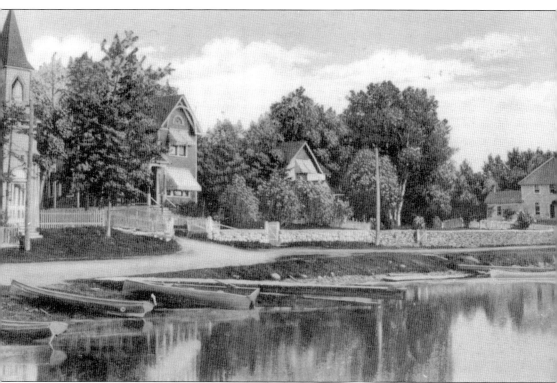

The Union Church served the people of Cedarville from 1891 to 1923. It was built through donations from Frederick R. Haynes and his employees. It was constructed for the Reverend Mr. Law to preach in, as he was holding services outside when weather permitted. In 1925, the congregation built a new church on Hodeck Street where it is still located. The church community added a fellowship hall to serve the community. It still serves the Les Cheneaux community.

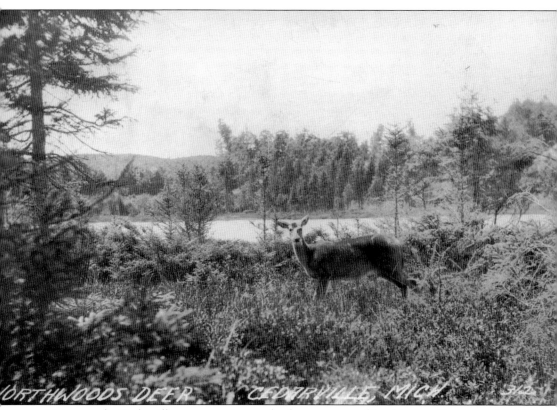

NORTHWOODS DEER CEDARVILLE, MICH. 342

Visitors to the Cedarville area came in search of nature scenes like this one. Deer were plentiful, and much of the area was untouched forest, as it still is today. The quest to find deer in their natural habitat was a popular pastime, and tourists would buy postcards such as this to remember the natural beauty found in the Les Cheneaux area.

Three

HISTORICAL HOTELS

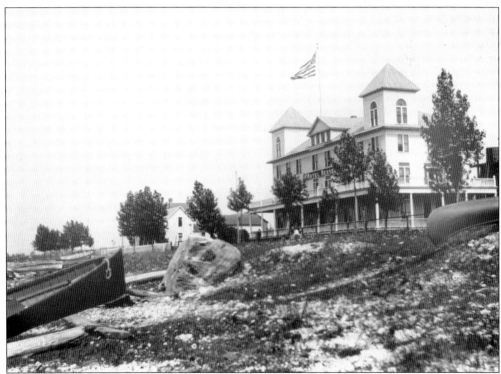

Spending summers in the Straits of Mackinac became popular with city dwellers in the late 19th century. People would travel from the Chicago or Detroit areas by train before transferring to steamships to reach the Upper Peninsula and the islands in Lake Huron. The Hotel Hessel was the first stop from Mackinac Island. It was a full-service vacation spot, offering meals, boats, and guided fishing trips, and thus a major attraction in the area. It was built in the late 1800s by John Hessel. It burned down in 1905 from a fire that started in the laundry.

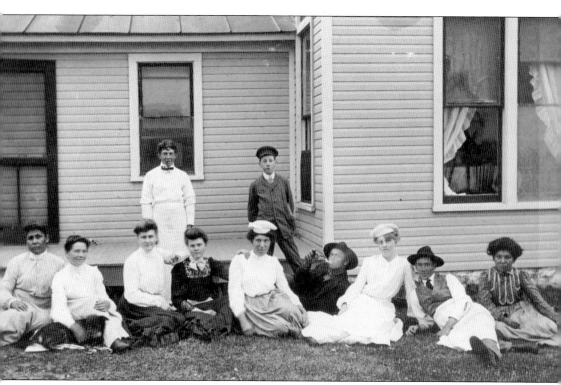

The success of any hotel was the staff that provided for the guests. This photograph is of the Hotel Hessel staff resting on the lawn behind the establishment. Operating a hotel of any size required many people to provide for the needs of its guests. Many visitors spent several weeks at area hotels escaping the heat of the city.

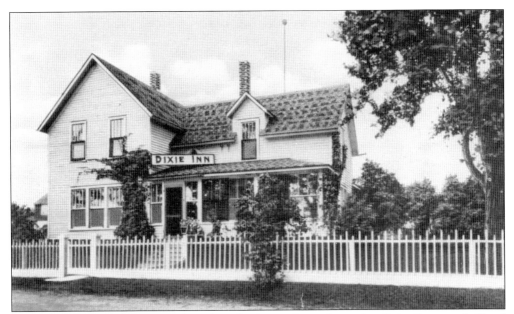

The Dixie Inn in Hessel operated as a boardinghouse. It was located on Lake Street and offered its guests a view of Hessel Bay. It was operated by Charles Hessel and his wife; it was later used as their residence and was razed in the late 20th century.

The Gateway Resort was located on Hessel Point. It was opened by Charles L. and Edna Gresehover in 1948. They operated the resort until 1952, when it was sold to Rose and Scott Sturtevant, the last owners. The cottages were sold individually, and most were torn down and replaced with houses.

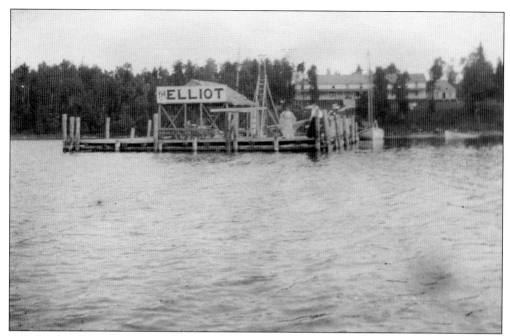

LaSalle Island was home to the Elliot House, which was built in the 1890s by Elliot Holbrook. In 1896, he sold the Elliot to Amos Beach. Beach's son John and his wife, Eliza, continued operating the Elliot and added dining-room services and a fishing guide. The Elliot became the post office for LaSalle Island for a short time.

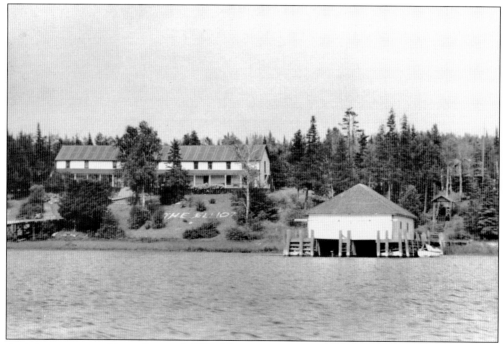

Arriving guests would see the words *Elliot House* written across the lawn as they approached the dock. To the right of the dock is a boathouse used to store boats and equipment. Boathouses are a common sight along channels.

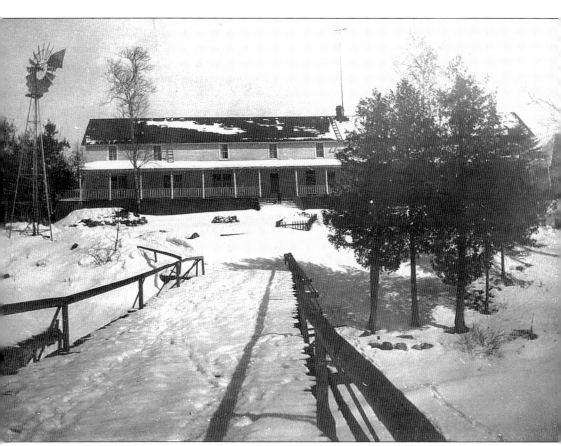

The Elliot House weathered many winters until it was razed in the 1950s. Business dropped off for the hotels, as guests no longer spent extended time at the various establishments during the summer. Modern travel made it easier for vacationers who could now access motels and cottages by car, and it became unprofitable to maintain the Elliot House.

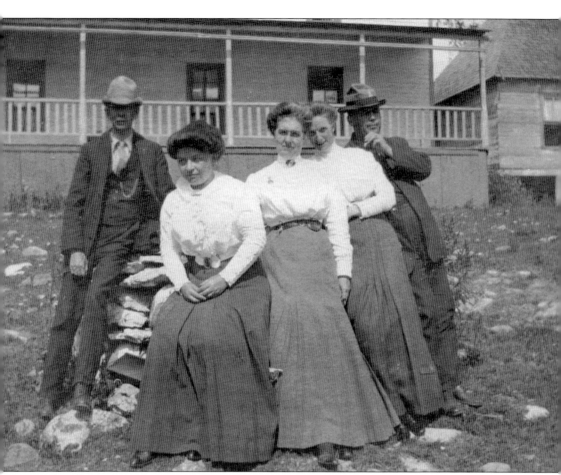

The Elliot House was a popular vacation spot on LaSalle Island. Several Elliot House guests take time to pose for a picture on the grounds of the Elliot in 1907. People came to hotels like this to spend leisure time, and socializing was an important part of vacationing.

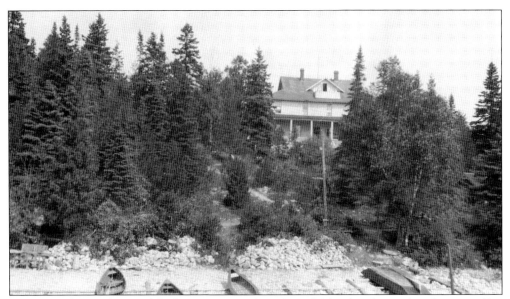

The Lakeside Hotel opened for business in 1895 on Coryell Island and served as the post office for a time. W.H. Coryell discovered island no. 5 while camping in the area. Having served in the Civil War, he was able to receive land from the government for a homestead. Since island no. 5 was owned by the government, Coryell made arrangements to live on the land for the required time and received his grant in 1894. He then built the Lakeside Hotel as part of Coryell-McBain investments, where the thought was to build a hotel and sell lots on the island. This was similar to the idea investors at the Les Cheneaux Club used to promote their land development.

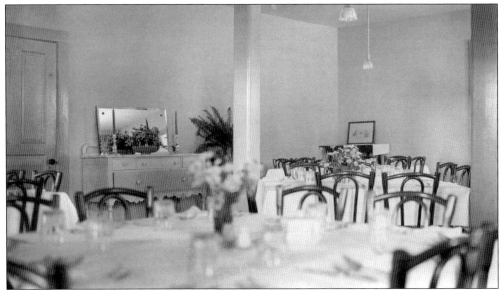

The Lakeside Hotel had 25 rooms and served as the post office for Coryell Island. In 1900, Eva McBain inherited the hotel from her husband and ran it until 1927 when his son Ralph took over. Eva added to the hotel while in charge. Her additions included a walk-in refrigerator that used ice cut from the water each winter. She also brought electric to the hotel. The Lakeside Hotel had cottages and tent platforms that guests could rent. This image shows the well-appointed dining room where guests took their meals while staying at the hotel.

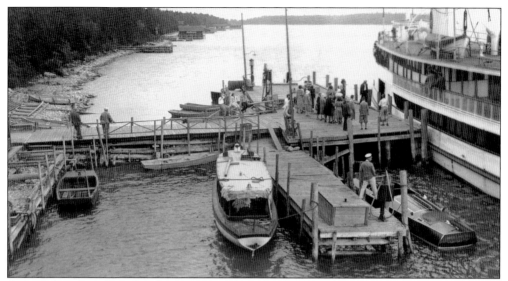

Guests arrived at the Lakeside Hotel (and the other hotels on the islands) by steamship, with steamer trunks in tow for their extended stay at the hotel. The Lakeside remained in business until 1953, when the steamships stopped running to the Les Cheneaux Islands.

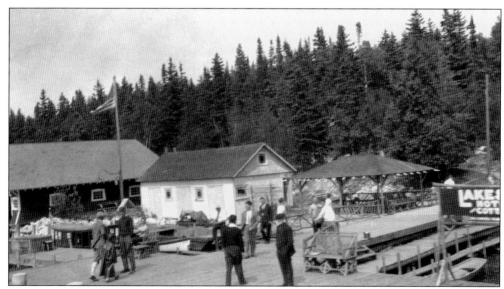

The Dock at the Lakeside Hotel was a very important place. Some guests would stroll the dock to enjoy the cool breezes off Scammon's Harbor, while others would take charge of their fishing boat to try their luck catching perch. The dock was also where all the supplies to run the hotel were delivered.

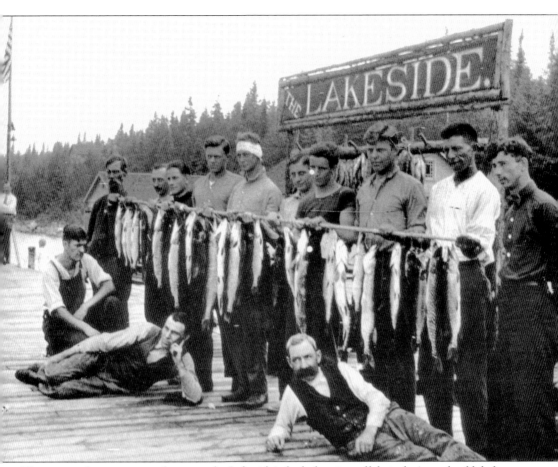

This image shows a group of men on the Lakeside's dock showing off their day's catch of fish from the local waters. The abundance of fish in the area was an attraction for many guests who spent their summers at the hotel. The Lakeside provided fishing boats for their guests.

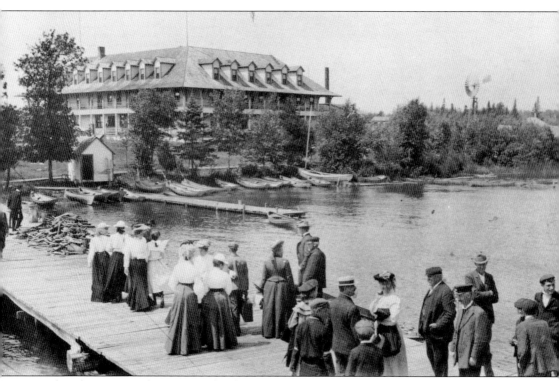

The Islington Hotel was a grand sight for guests arriving at its attractive dock. Milo Melchers and his wife, Rose (Stroh), first built a cottage on Melchers' Point. After their first summer, plans were made to build the hotel. Construction started in April 1895, was completed in July, and the Islington Hotel opened for business. Rose was not in favor of the business, but it became her life for the next 50 years.

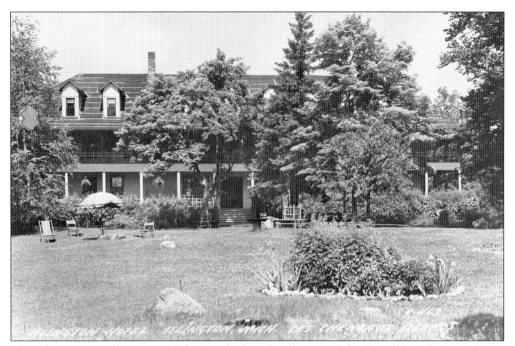
The Islington Hotel was one of the best-looking hotels east of the Grand Hotel on Mackinac Island. This view is of the lawn with its lovely trees and lawn chairs that provided an inviting place to relax and enjoy the breezes from the water. (Courtesy of Superior View.)

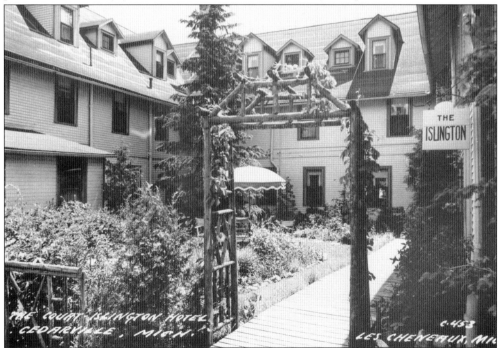
Guests could find a quiet place to relax outside the Islington to enjoy the moderate weather. This became the hotel's main entrance when guests began arriving by cars rather than by boats. Spending time outside with nature was a main reason people traveled to the Les Cheneaux Islands.

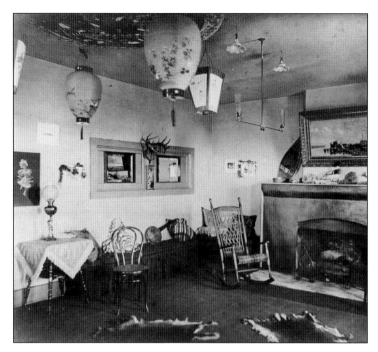

Rose Melchers was not pleased with the interior of the hotel, because the furnishings were purchased from a Detroit hotel and were not the best quality. She took a disliking to the white walls and went to work to change the decor to make it more suitable for guests. This 1898 image of the living room shows the gas lighting that was an important improvement for hotels of the era. The room is nicely appointed with deer-hide rugs and Chinese lanterns.

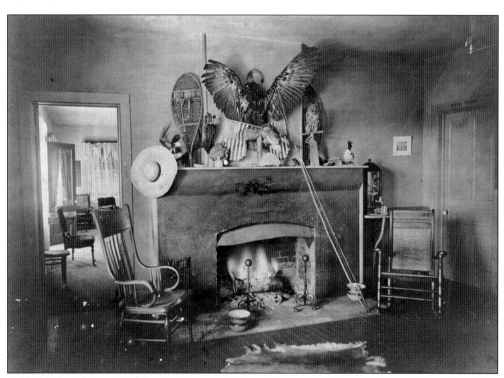

In 1898, the Islington's lobby fireplace was adorned with snowshoes and a stuffed eagle, giving the room a rustic feel with the deerskin rugs on the floor. Like most places, the Islington was this way because shipping fancy decor was expensive.

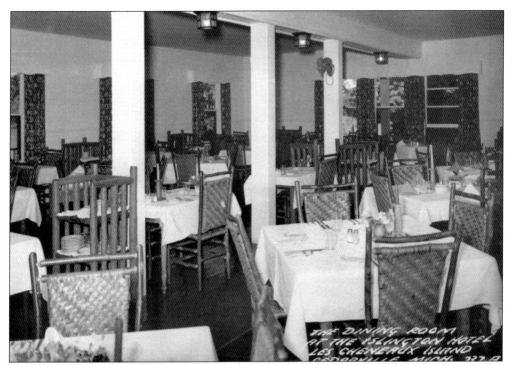

The Islington's dining room was pleasantly decorated with rustic chairs and white tablecloths; guests would take their meals here. Often times, the chef would prepare the fish guests would catch on their trips in the channel. According to Mrs. Melchers, this was a favorite meal.

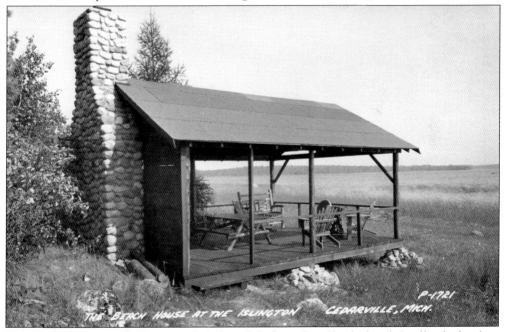

The Beach House provided guests with shelter while they relaxed by the beach. It offered a fireplace and a place to picnic by the shores of the bay, which its beauty was a great attraction. Spending time on the shore in the cool breezes off the water was a popular activity.

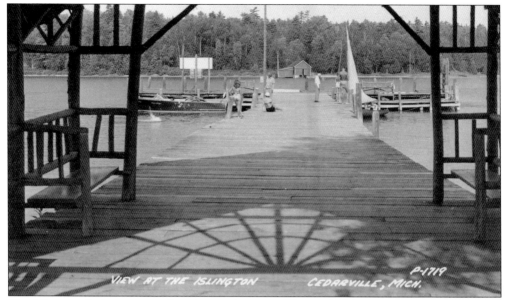

The Islington dock was a popular place with guests. This mid-20th-century photograph shows a Chris-Craft boat that was a very popular choice in the Les Cheneaux Islands. Guests relaxed on the dock or accessed fishing boats that the Islington provided. Guests could also use a fishing guide the hotel employed. The Islington was razed during the summer of 1960. Like the other hotels in the area, the cost of insurance and the declining clientele made the establishment unprofitable to continue operating.

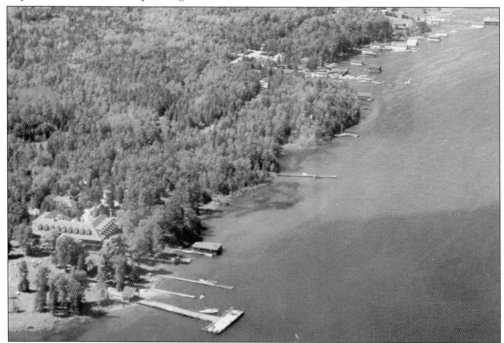

The Islington Hotel and dock are in the foreground of this aerial view of Islington Point. This image documents how secluded it was on Islington Point and shows the water tower that provided water for the hotel. (Courtesy of Helen Melcher Wells.)

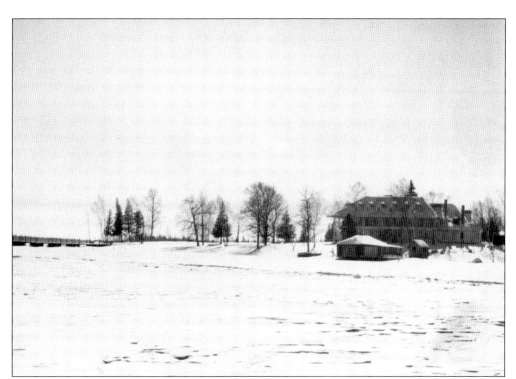

When summer ended and the last guests left for the season, the hotel was closed up and left to weather the winter on its own. This is a 1959 photograph of the Islington standing during its last winter.

The Islington was an AAA-approved hotel. AAA advertised hotels for their members, and its logo assured the lodging was a quality place to stay. This advertisement board for the hotel promoted it as an outstanding resort in Michigan's Upper Peninsula.

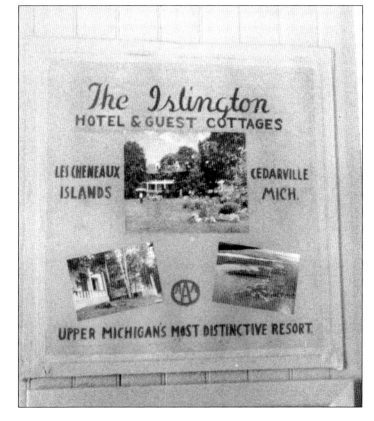

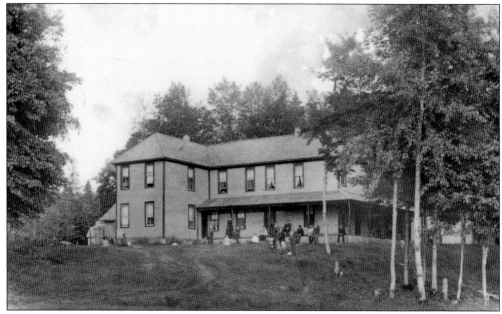

Patrick's Hotel was a mainland establishment built on the Les Cheneaux Channel around 1887. The hotel had the distinction of serving as the first post office in the area. It was constructed by William Patrick, who later sold it to Sam Meik in 1893. Meik renamed the hotel the Pennsylvania Hotel because he was from Pittsburgh. The Pennsylvania Hotel is near Patrick's Landing. The Pennsylvania burned in 1946.

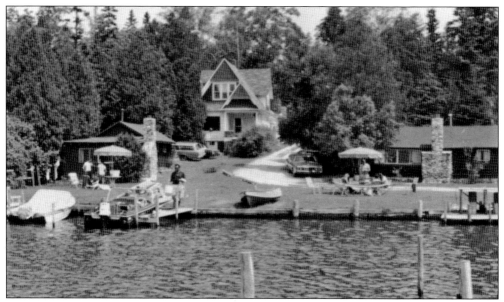

Patrick's Landing is still in operation today. This mid-20th-century photograph depicts guests enjoying the outdoor amenities that drew generations of visitors to the resort. It is now called the Les Cheneaux Park Cottages.

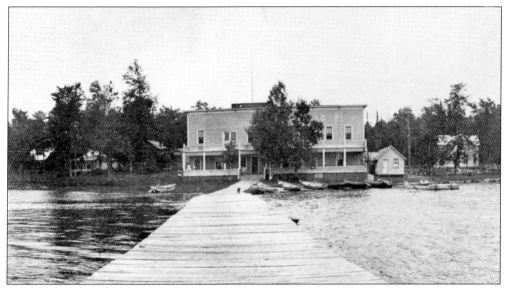

The Snows Hotel was on Park Avenue down from the Pennsylvania Hotel. It was built around 1890 by William Williams. The hotel changed hands several times; Charles Hessel owned it before selling to Fredrick Meyers, and then the Hendricks family later owned the establishment. Like most hotels of that era, the Snows Hotel's fate was met by a fire in the late 1940s.

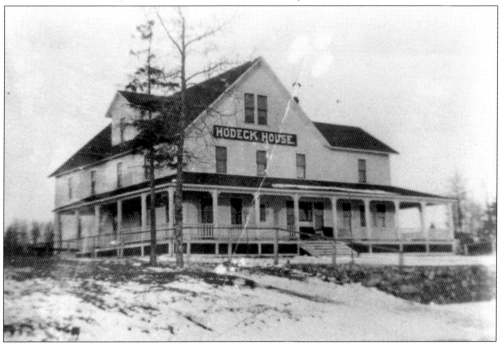

The Hodeck House was originally the Mattson boardinghouse, which served as lodging for men working at the lumber mills. Vance Hodeck purchased the boardinghouse from the Mattson brothers and moved his family there. He built a home and continued to operate the Hodeck House, focusing on the seasonal resort business. The family sold the Hodeck House to Thomas H. Shepard in 1912, and Shepard eventually sold it to H.P. Hossack in 1921, taking the name Cedar Inn.

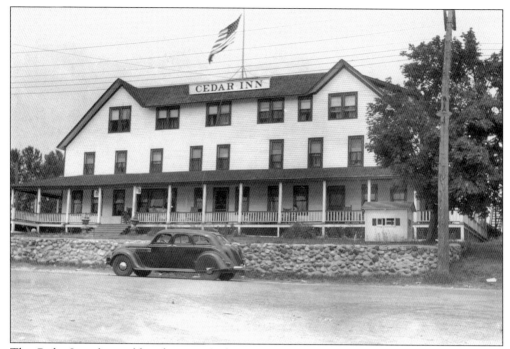

The Cedar Inn changed hands in 1945 when Cliff Gerdin bought it. He operated the business until 1960 and then sold it to Georgia Linderman. She made improvements to the inn, but business never was as good as it was in the days of the grand wooden hotels. The Cedar Inn was razed like many of the other glorious wooden hotels in the Les Cheneaux area.

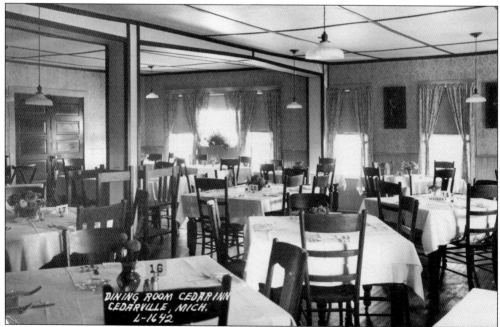

The dining room of the Cedar Inn was a popular place for visitors. On Sundays, a roast duck dinner was served that brought many guests to the inn. It is said that people traveled from as far away as Sault Ste. Marie to have the roast duck dinner.

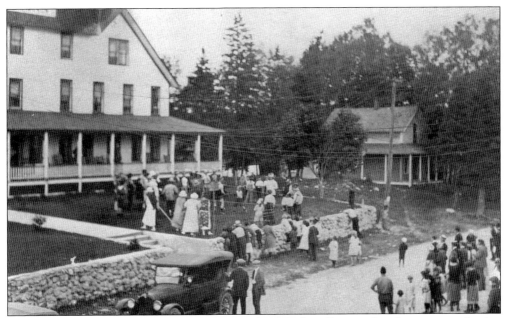

The Cedar Inn's lawn was a place for the people of Cedarville to gather for activities. In this photograph, onlookers watch as a man and a boy engage in a boxing match. Any event was an occasion to get dressed up in fine attire.

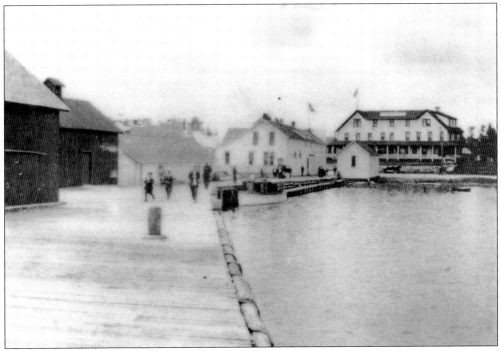

The Cedar Inn was built across the street from the waterfront in Cedarville. This location had the advantage of a splendid view of Cedarville Bay but was also convenient for guests arriving on the Hossack Dock, which is in the foreground.

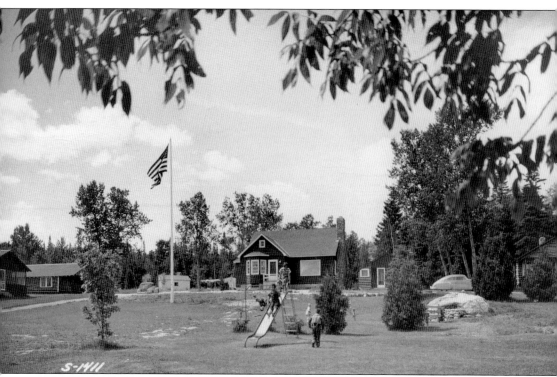

The Victor Shoberg Resort was built between the years of 1927 to 1933 by Victor and Anna Shoberg with the help of their son Raymond. Victor and Anna worked at the Islington Hotel for over thirty years. When Victor and Anna retired their youngest son Conrad and his wife Helen took over the resort and added two modern rental cottages in the mid-1960s. This mid-20th century photograph depicts Conrad and Helen Shoberg's children playing on a slide in front of their home. The original cottages were moved to other locations in the area, and the two modern units were sold in 2000.

Four

LES CHENEAUX ISLANDS

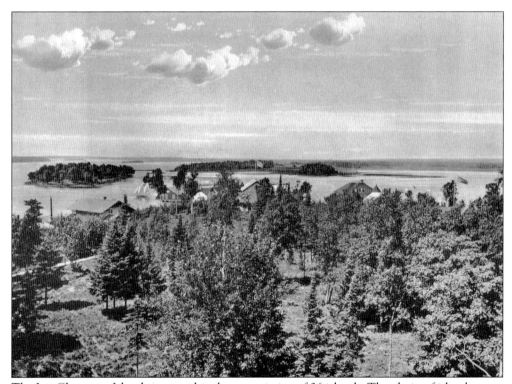

The Les Cheneaux Islands is an archipelago consisting of 36 islands. The chain of islands spans from west of Hessel to east of Cedarville; the largest island is Marquette Island. The Les Cheneaux Club is found on Marquette Island, and this photograph is an aerial view of the club and the homes that grace Club Point. The club's property was bought in 1888.

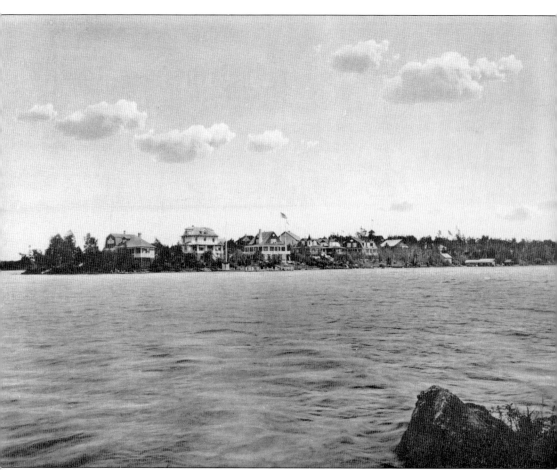

The Les Cheneaux Club was incorporated in December 1888 in Bay City, Michigan. It was organized as a resort association under the Michigan Public Act of 1877, which allowed associations to form for the common interest of leisure pursuits. However, the relationship was more complex, as the original four first members' interest was in developing an investment group to sell resort property. This image shows the stately summer cottages on Club Point.

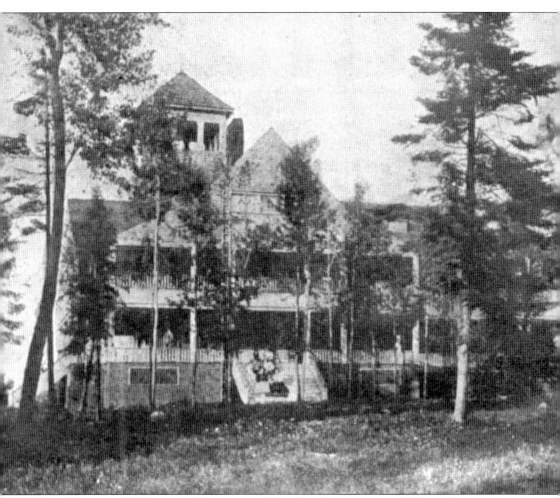

The Les Cheneaux Clubhouse was built to provide a place for prospective club members to stay while they bought land and built summer homes. It was open for members and their families. This photograph is the original clubhouse, which opened in 1889. This was a much smaller structure, near the caretaker's cottage, than what can be seen on the next page.

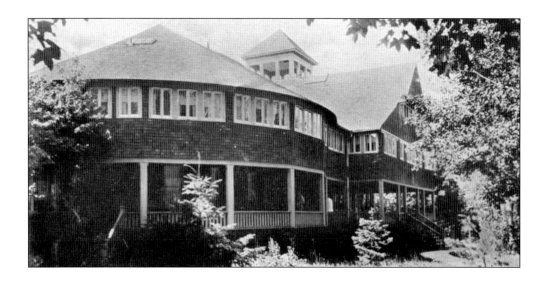

The big clubhouse pictured above was completed in 1901 and opened for that summer season. It was necessary to make the improvements so that a water and septic system could be built. The second clubhouse had hotel rooms and a dining room where most club members took their meals. Members could use the clubhouse for family and guests who stayed at the club. The Les Cheneaux Club was dissolved on August 6, 1901, and reincorporated under the Summer Homes Act of 1889. This gave the association more control, because the 1889 act made all the land private.

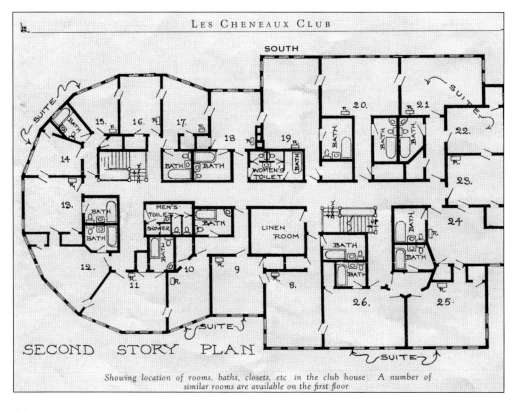

Showing location of rooms, baths, closets, etc in the club house A number of similar rooms are available on the first floor

Saturday-evening dinner and dancing was a dressy affair. The photograph at right, taken in 1955, is of the clubhouse porch during Mike Fels's 10th birthday party. Even children were required to dress up for the Saturday-evening activities. Children also spent many hours enjoying outdoor activities at the club. Below, Mike is busy playing on the Baker Fels dock. (Both courtesy of Charles Fels.)

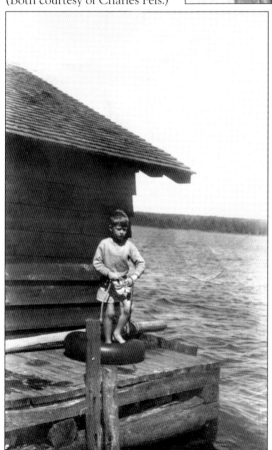

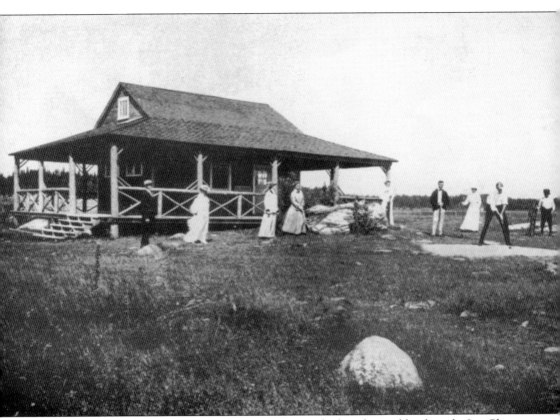

The Les Cheneaux Golf Club was chartered in 1889, which makes it older than the Les Cheneaux Club itself. It is also one of the oldest golf courses in Michigan. Along with the golf course, there was land that was used for growing vegetables. This helped to sustain the club dining room, as all other supplies had to be shipped in. The golf club property also made access to the club easier, because it was just a short trip across Club Cut.

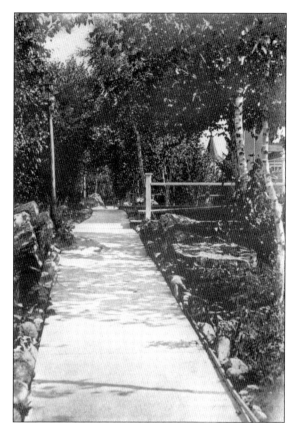

The grounds of the Les Cheneaux Club had a natural beauty to them. Improvements, such as sidewalks, were made, but the trees and rocks common to the area were retained to create a pleasant outdoor experience. The chimney from Shab-wa-way's cabin was maintained on the property of the club for many years. There is now a plaque where the chimney once stood.

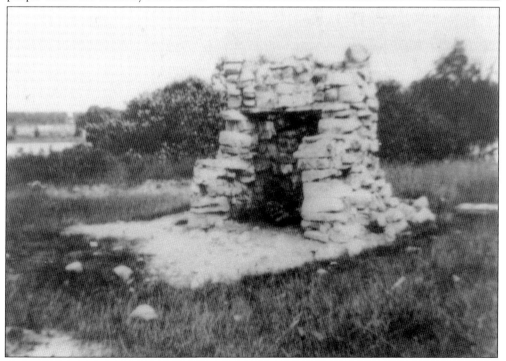

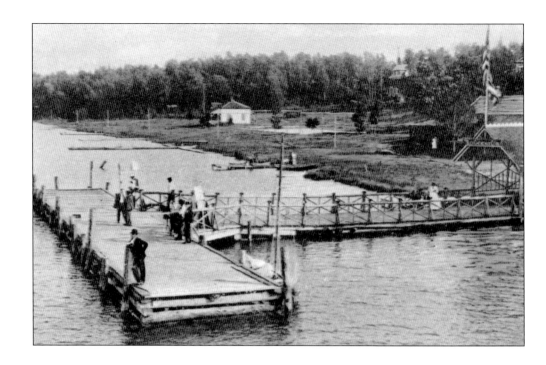

The Les Cheneaux Club dock is a landmark in the Snows Channel today. These two photographs show the dock in the early 1900s (above) and later in the 20th century. The dock was an important place, because members and guests would arrive at the dock by steamship in the early days, and supplies were also shipped there. In the more recent image, a horse and cart wait by the dock to transport supplies and luggage for the club members.

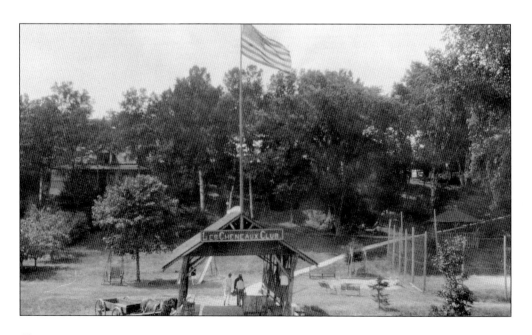

Michigan Department of Health
Lansing
Resort Sanitation

This is to certify that LES CHENEAUX Club

HAS BEEN DULY INSPECTED AND HAS BEEN GIVEN THE FOLLOWING RATING:

	PERFECT SCORE	SCORE AWARDED		PERFECT SCORE	SCORE AWARDED
WATER SUPPLY	20	16	GROUNDS	10	10
SEWAGE DISPOSAL	20	18	FOOD HANDLING	10	9
MILK SUPPLY	20	14	BATHING	10	5
GARBAGE DISPOSAL	10	10	GENERAL RATING		82

RATINGS BELOW 70 PER CENT ARE UNSATISFACTORY

INSPECTION NO. 52 MACKINAC

DATE OF INSPECTION **1937**

Edward H. Rich

DIRECTOR, BUREAU OF ENGINEERING

These documents are from the Les Cheneaux Club. Although it was private, the Michigan Department of Health inspected the club's dining and sanitation system annually as it would at all resorts. This is the club's 1937 certificate of satisfactory standards. The membership card was used by the board of directors to grant summer privileges to guests of the club, who had to be sponsored members of the club.

AT THE REQUEST OF

MR _____

THE BOARD OF DIRECTORS OF

LES CHENEAUX CLUB

EXTEND TO

MR _____

THE PRIVILEGE OF THE CLUB FOR THE SEASON OF

_____ SUBJECT TO ITS RULES

GOVERNING GUESTS.

E. H. NELSON
SECRETARY.

KIRK HAWES,
PRESIDENT.

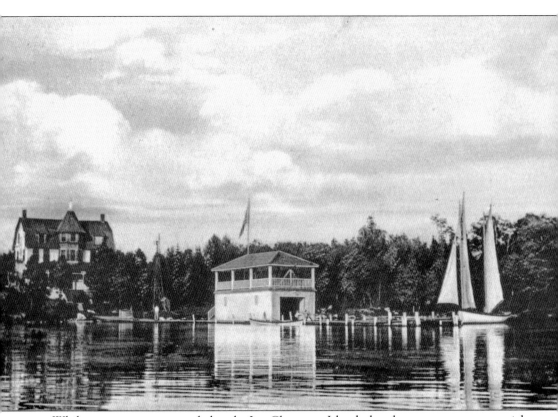

While garages were not needed at the Les Cheneaux Islands, boathouses are a common sight at each cottage. Most residents had more than one boat, and storing them in a boathouse offered protection from the weather and made using them more convenient.

Dollar Island is a landmark in Snows Channel. In 1901, Roger Whitlock bought the island and used it as a summer home. As these photographs show, the home changed through the years, but the effect is still the same: it appears as a house in the middle of the channel. There is not much land around the house.

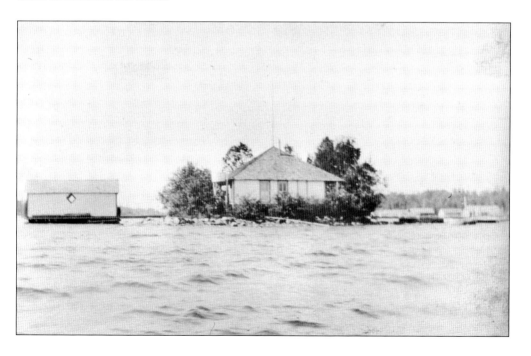

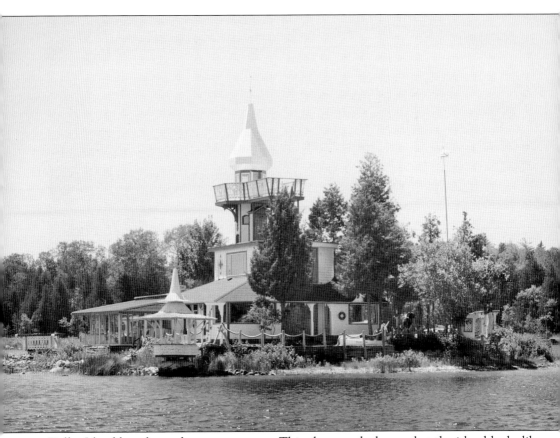

Dollar Island has changed over many years. This photograph shows what the island looks like today. The house has been altered, and every available bit of land is used. (Author's collection.)

Two islands have similar names: Little La Salle Island, which is privately owned, and LaSalle Island. La Salle is the second largest island in the chain, is home to Cincinnati Row, and is across from Islington Point. It takes its name from the hometown of the residents who built cottages there. La Salle Island has many bays, one of which is Urie Bay, shown here. This house overlooks the bay from a slight hill.

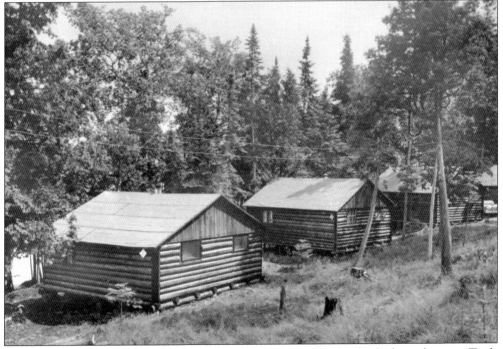

Log cabins were popular in the early 20th century. This is Hill Island, which was home to Trails End Cabins. They were rustic structures rented by people seeking a summer retreat from the heat of the city. Cabins like these were in high demand. Often times, the only place for rent available was a piece of land to pitch a tent on.

Bush Bay has remained untouched over time. These two photographs show the beauty of the bay unaffected by man and improvements. The bay offers safe cover for anglers to cast their lines. Rock Shore is aptly named because of all the rocks between the land and the water. These rocks are common in the area and create shoals in the water that can be hazardous to careless boats. Bush Bay is most often accessed by small boat.

There are three main entrances to Les Cheneaux Islands. The middle entrance in the photograph above is very shallow and is not accessible by large boats. There are rocks and very shallow water near the opening to Lake Huron, and this passage is difficult for large boats to maneuver. Another entry point is the west entrance, which leads out into Lake Huron to Mackinac Island. Navigation in this area can be challenging as well because of rocks, like those near Haven Island seen below. Haven Island was undeveloped through the 1950s but now has one cabin on it. The third access point is the yacht entrance near Government Island on the south end of Scammon's Harbor. There is also a deep passage called the East Entrance between Coryell Island and the mainland. It is a deep entrance that is easier for large boats to navigate.

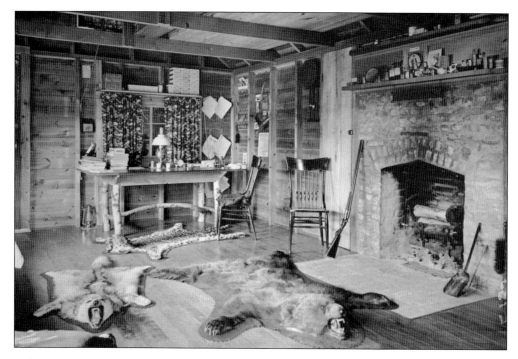

Cabins on the islands were very rustic. The interior view of the *Kilkare* living room in 1907 gives a sense of how rustic the construction actually was. The interior walls reveal only bare studs and exterior siding, oil lamps were used for lighting, the fireplace provided heat, and the furnishings were rustic as well. Tanner Cottage was similarly furnished with simple furniture. The cabins did not offer much protection from the heat or cold.

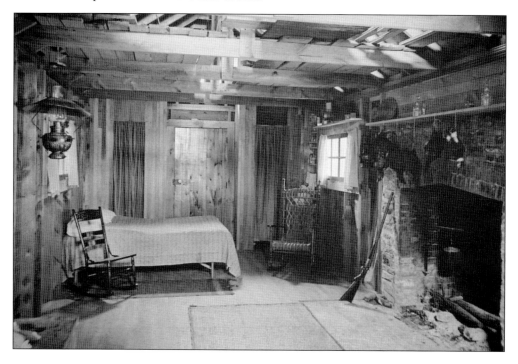

Andrew Tanner built his home on Coryell Island. He was known in the area for his photographic work, capturing life in the Les Cheneaux Islands. In these two images, Tanner documents his home, which he called the Ark. Stone was plentiful on the islands, and this chimney was built out of the native rock.

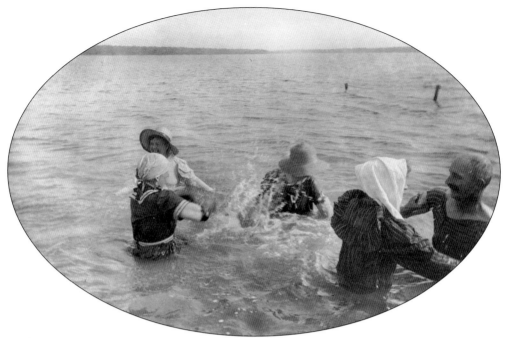

Andrew Tanner captured a group of women swimming in Lake Huron. Life was full of leisure activities for summer residents, as the northern weather was milder than in the cities. People enjoyed outdoor activities, like the group of women below playing a lawn game. Whatever the activity, people always dressed for the occasion.

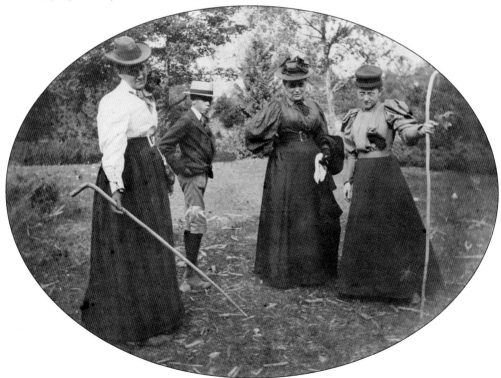

Docks provided a great place to dive into the waters of Lake Huron. Andrew Tanner has captured men making use of the dock for a diving platform, while the women watch the fun from the dock. People would pass their time with all types of leisure activity, including just sitting on the dock watching the fun.

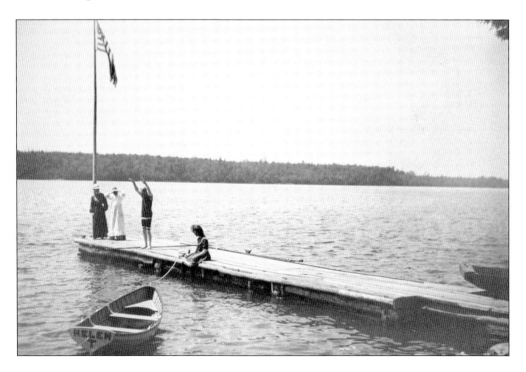

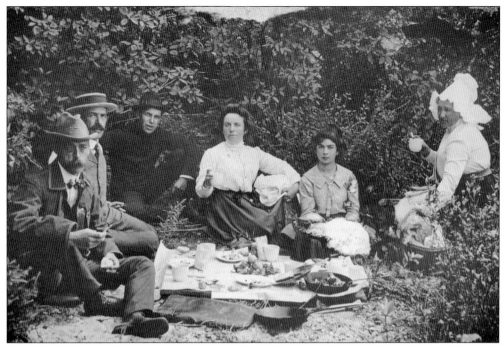

Outdoor activities became very popular in the 1900s. People had more leisure time and wanted to experience nature and self-reliance. Most people lived in urban areas, so opportunities with nature were limited to those who could travel to natural, rural areas. Outdoor meals were popular activities; they allowed the participants to prepare meals using a more primitive method of cooking. Although dinner was served on the ground or on makeshift picnic tables, Victorian customs of proper dress were still followed.

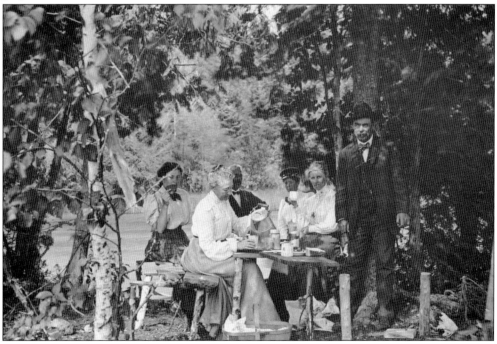

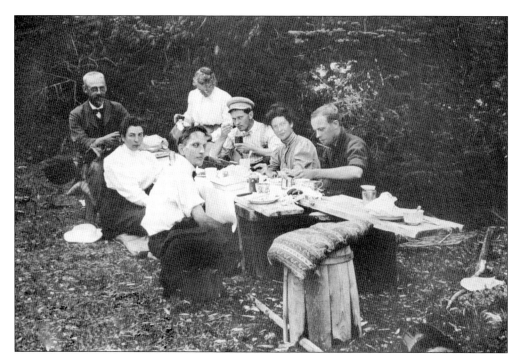

A popular meal at the picnics was a fish fry. Anglers would take to the bays around the islands and catch fish to be cleaned and cooked on an open fire and served. These photographs from 1906 depict people gathering in small and large groups to enjoy the pleasures of a fish fry. Perch and whitefish were abundant throughout the area during this period. It was not hard to catch enough fish to feed a group of people of any size.

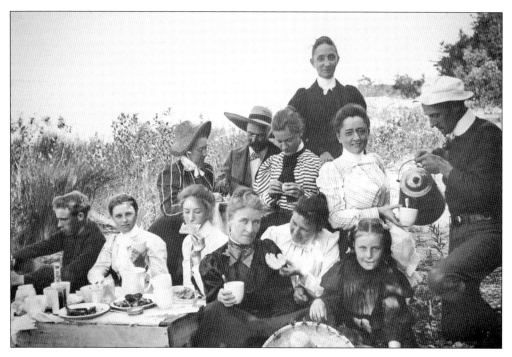

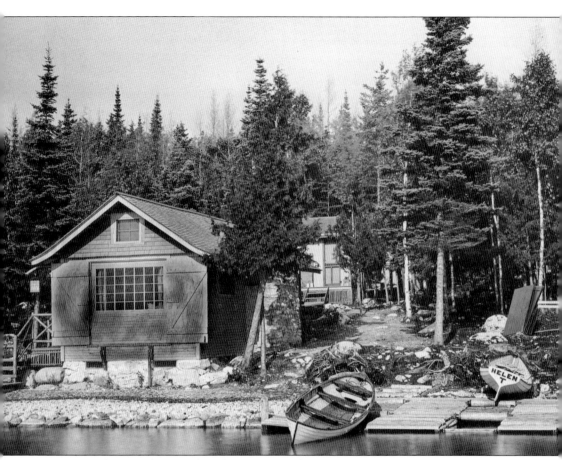

Tanner took many photographs of his property. This image shows a building near the water. The vessels on the shore are ready for use. In the winter they would be stored inside to protect them from the harsh winters.

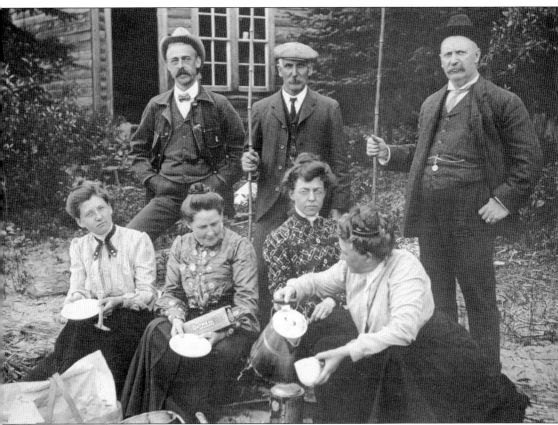

Picnics were not always out in the woods in a secluded bay. Oftentimes, people cooked outside their cabins on open fires. While the women are pouring coffee brewed on the fire, the men pose with their cane poles that were commonly used for fishing. Outdoor cooking helped keep the cabin cool and free from the smell of fried fish—that always made sleeping more enjoyable.

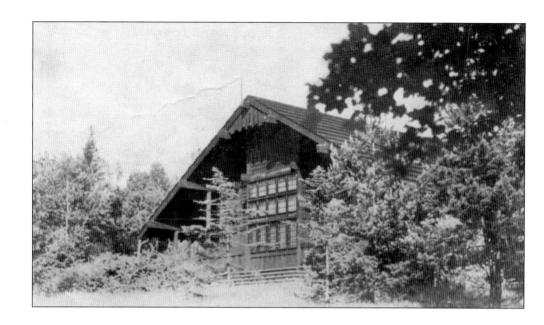

Pleasant Point on Marquette Island is the home to the Les Cheneaux Yacht Club. The boathouse, which is now the yacht club and caretaker's cottage, was built in 1913 by Arthur H. Fleming. He was from California, was in railroading, and was part of the Statler Hotel chain. In 1914 and 1915, the main lodge, electrical generator, and pump house were added. The entire complex is built out of Florida Cypress wood that was shipped by rail to Detroit and then brought to the area by barge. Fleming only owned the property a short time when he sold to Joe Gardolski.

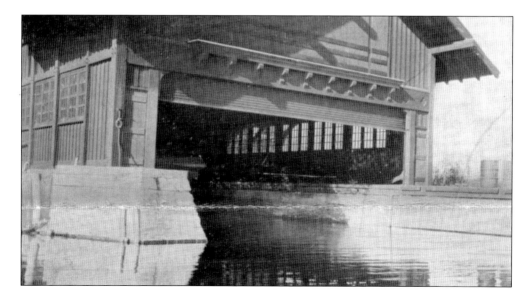

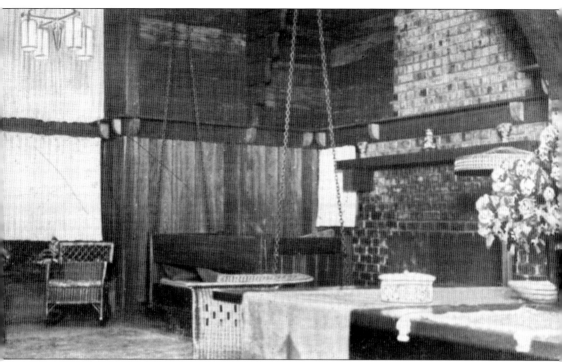

Several people from Cincinnati Row decided that the Les Cheneaux area needed a yacht club and founded an organization on August 7, 1937. Two years later, they bought the Pleasant Point property from Joe Gardolski. In 1946, the lodge and some property were sold to raise funds to maintain the boathouse. Paul Gerwin, from Ohio, bought the lodge, and it remains in his family today.

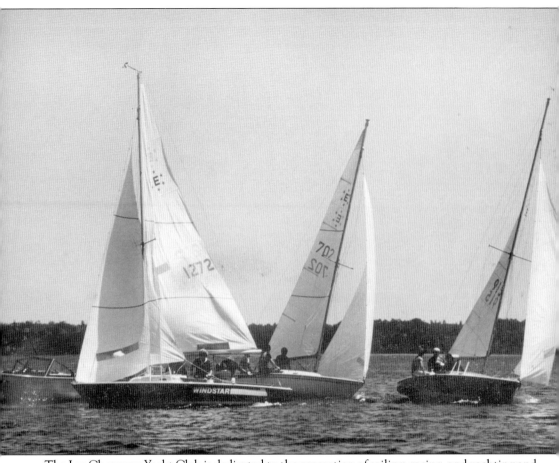

The Les Cheneaux Yacht Club is dedicated to the promotion of sailing, racing, and yachting and is home to Ensign Fleet 31. It is the largest Ensign fleet in the country, and it holds membership in the National Ensign Class Association. In 2010, the Les Cheneaux Yacht Club hosted the National Ensign Regatta. (Courtesy of the Les Cheneaux Yacht Club.)

Five

THE NECESSITY OF BOATS

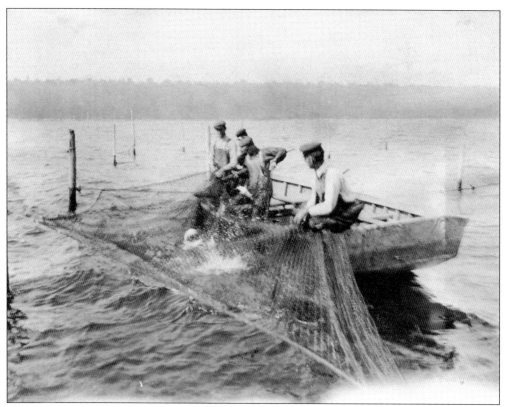

Many men in the Les Cheneaux area relied on their boats to make a living. Here are four fishermen hauling their nets into a small, flat-bottomed boat used for fishing. The low sides of this craft made it easier to bring the nets in. This was an early commercial fishing operation around the turn of the 19th century.

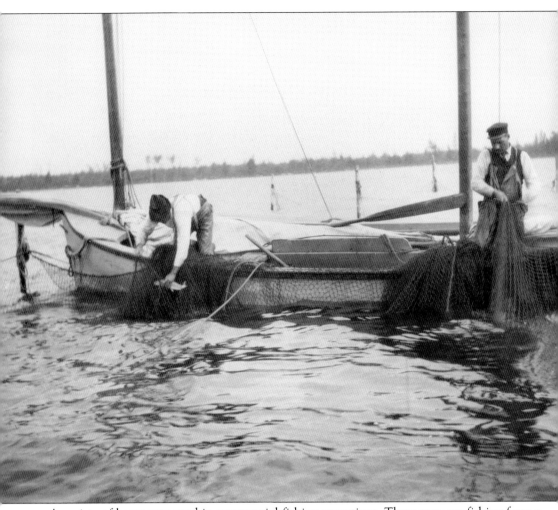

A variety of boats were used in commercial fishing operations. These men are fishing from a sailboat, which was equipped with sails to make travel faster in the channels. This vessel also has low sides, which make the hauling of nets more efficient.

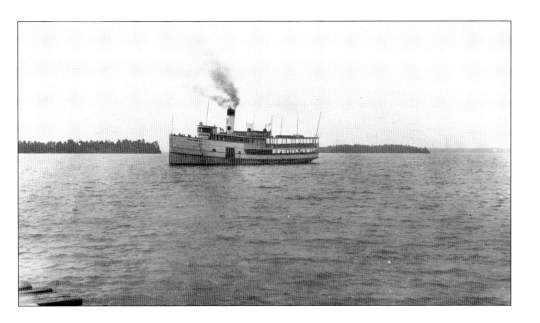

Once a resort community was established in the Les Cheneaux area, steamships became a common sight on the water of the bays and channels. The steamships would meet the trains in the Lower Peninsula and transport passengers to the Les Cheneaux area. They would stop at Mackinac Island and continue on to the Les Cheneaux Islands as well as to docks in Hessel and Cedarville.

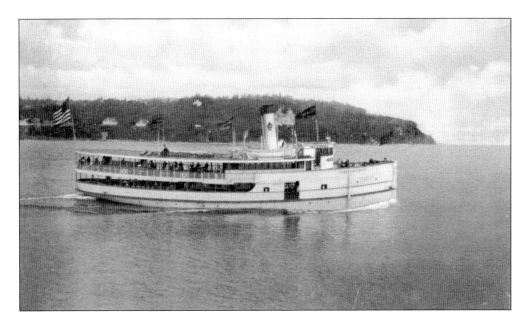

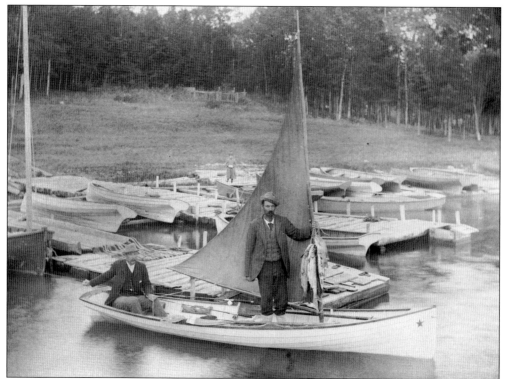

Not all professional fishermen ran commercial operations. This photograph is of a fishing guide who displays the catch for the day. Most of the hotels employed fishing guides for their guests. Sportfishing was a popular pastime of summer visitors because of the abundance of fish in the Les Cheneaux Islands. This guide used a small sailboat, which made travel faster but required special boating skills to handle.

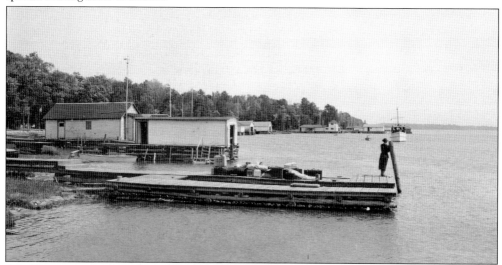

A man waits on the dock to greet passengers on the approaching boat. Steamships kept a schedule of arrival and departure from each of the hotels in the Les Cheneaux area. Luggage and supplies on the dock await the owners. Luggage was frequently delivered by a different ship before the passengers arrived at their final destination.

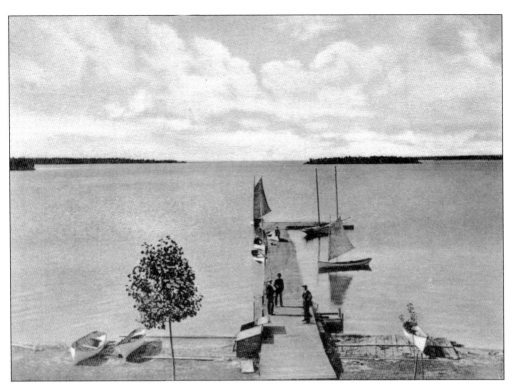

Boats could always be found tied to the Hotel Hessel dock. On the shore are a couple of small rowboats that were used as a means of transportation from the mainland to the islands.

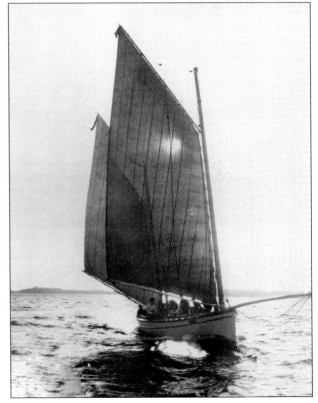

Mackinac boats were a common sight in Les Cheneaux Channels and the surrounding waters of the Les Cheneaux area. The Mackinac boats were gaffed-rigged crafts that were used for multiple purposes. They were larger than the smaller sailboats, so they were well suited to transport supplies as well as being a means to transport people around the islands and mainland.

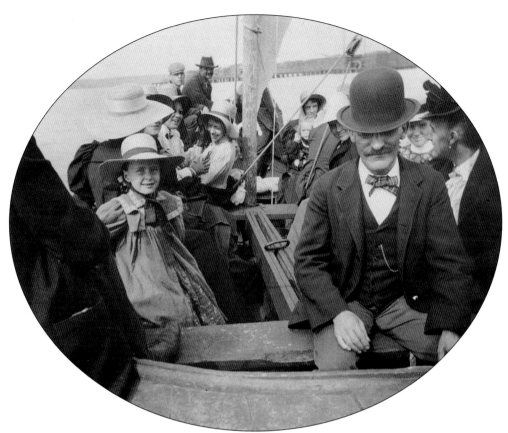

These Andrew Tanner photographs, taken at the beginning of the 20th century, depict groups of people sailing in the Les Cheneaux area. Although almost everyone was on summer holiday, they still dressed for the occasion. Dressing meant wearing hats for everyone; women's hats were always elaborate.

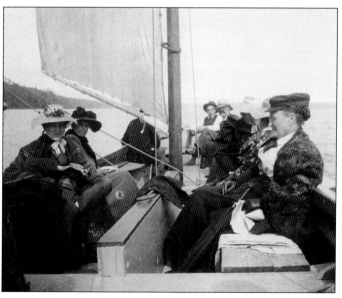

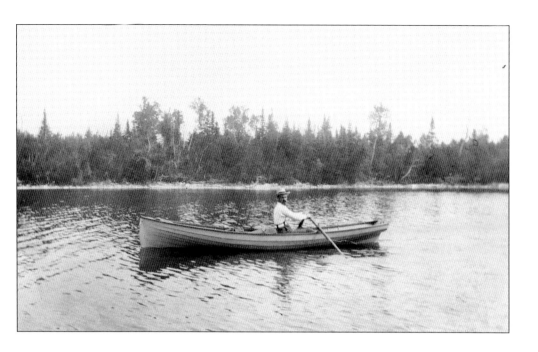

Andrew Tanner captures the beauty of these long, sleek rowboats. The boats were steered from the rear with a tiller, while the oarsman sat mid-ship to row the boat. These crafts were used for pleasure cruising in the water; they were also well built for fishing.

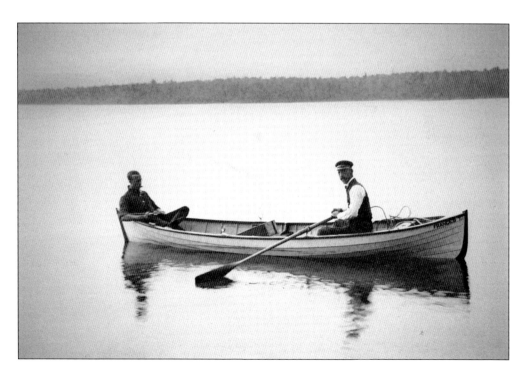

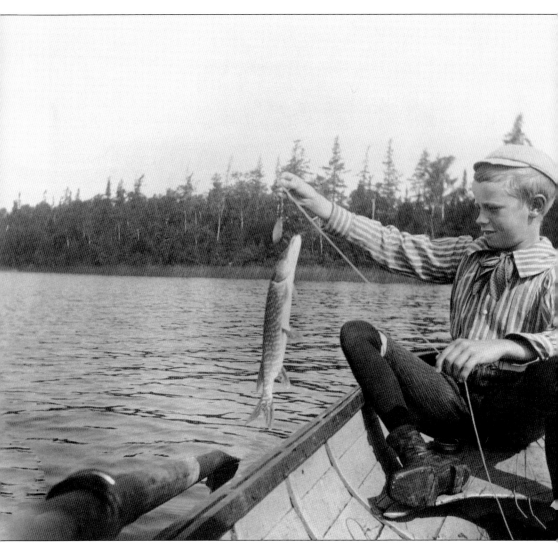

A young lad displays a northern pike he caught while fishing the area waters. Children as well as adults caught fishing fever in the Les Cheneaux area, and they were plentiful in Lake Huron at the beginning of the 20th century. All that was needed was a rowboat and fishing pole, and dinner could be caught with just a little time and patience.

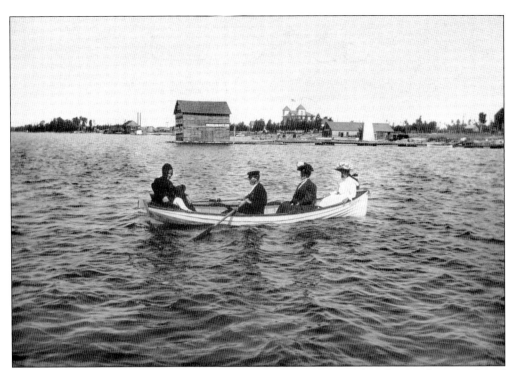

This rowboat, the *Chippewa*, was owned by the Paul Brobst family. The family and a friend are rowing about Hessel Bay. Gross Meyer (left) steers the little craft, while Porter Johnson rows it; the women are unidentified. This boat is now part of the collection at the Maritime Museum in Cedarville.

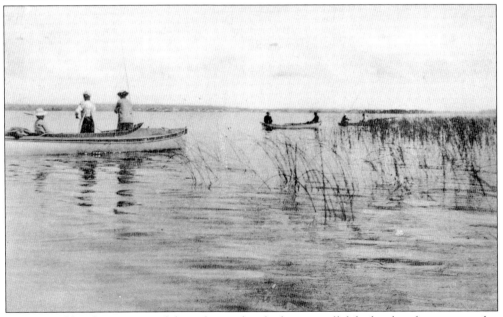

Visitors and locals spent time fishing for perch, which is a small fish that has firm meat and is mild in flavor—a favorite of everyone. Both men and women fished in the area, and as can be seen, women still wore hats.

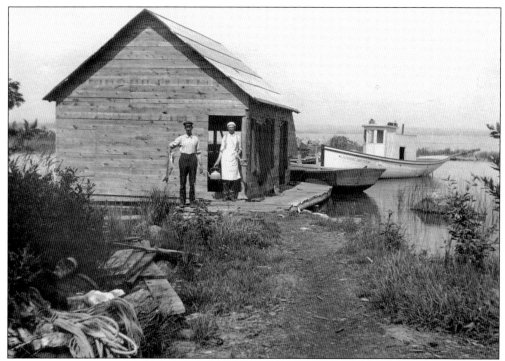

Two men display a catch of fish before it is cooked for lunch. Small buildings constructed on the shore of Point Brulee were common. Two vessels tied to the dock are commercial-type boats, while the flat-bottomed boat was commonly used for leisure fishing.

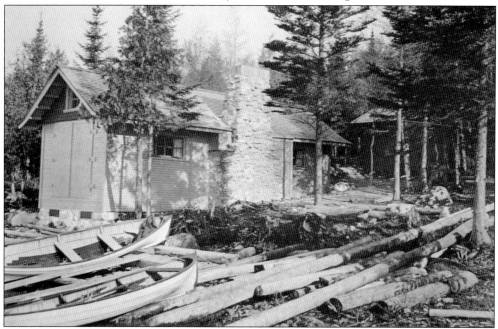

The Ark was one of the buildings Andrew Tanner erected on his property on Coryell Island. It was built alongside the water. It was a small cabin with a fireplace, and Tanner could easily access his boat from this location. The structure was completed in 1904.

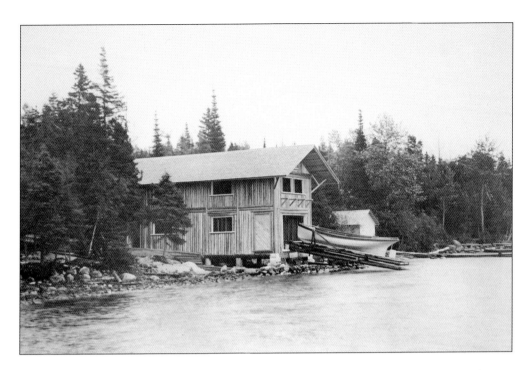

Tanner photographed this boathouse in 1907, which was built to house the launch *Eleanor*. Launches were popular boats outfitted with small engines midship. This improved the pilot's ability to navigate waterways without depending on wind or manpower. *Eleanor* was one of the early examples of this kind of vessel in the area. Another benefit of launch boats is the capacity to hold many people and supplies.

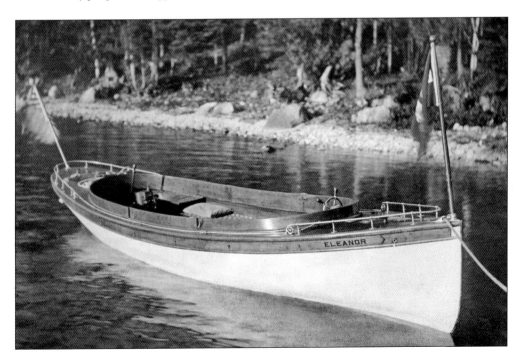

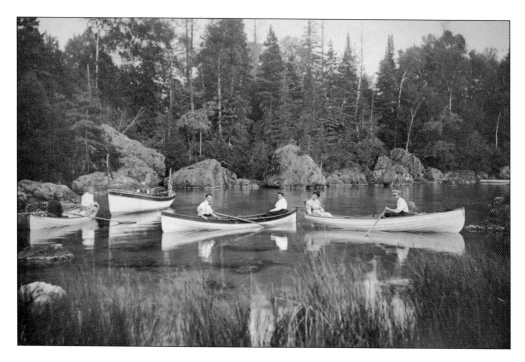

Bush Bay was a popular place for boaters to gather. The 1906 photograph above was taken by Andrew Tanner. It depicts a group of people in rowboats and a launch in Bush Bay enjoying a summer afternoon. The 1996 photograph was taken in the same place in Bush Bay. A Boston whaler is in the center, and two launches join in on the fun. In 90 years, Bush Bay remains unchanged. Only the boats and the clothing explain the era of the photograph.

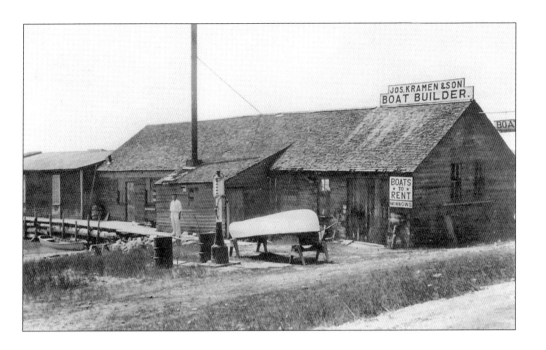

Joseph Kramen & Son Boat Builder was a Hessel business. Boat building was an important trade in the Les Cheneaux area because nearly everyone relied on boats for transportation. Kramen opened his business during the first decade of the 20th century. Inside the shop are two vessels being built. Boat builders had to be able to construct several different types of crafts to meet customers' needs. A Kramen-built launch, *My Bill*, was the featured boat at the 2011 Antique Wooden Boat Show. Kramen's was located where the public beach in Hessel is today.

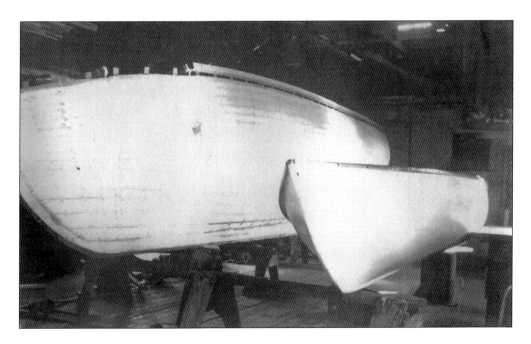

In 1915, Louis Folmer opened Rendezvous Boat Works, a marina and boat-building business. The marina carried Hacker-Craft, Kermath engines, and Scott-Atwater and Champion outboard motors. Hacker-Craft was a mahogany boat that was built for speed. Folmer also built a line of 24-foot launches in Cedarville. To get the boats from the storage building to the water, Folmer installed a marine railway that could move very large boats. This is now the location of Viking Boat Harbor.

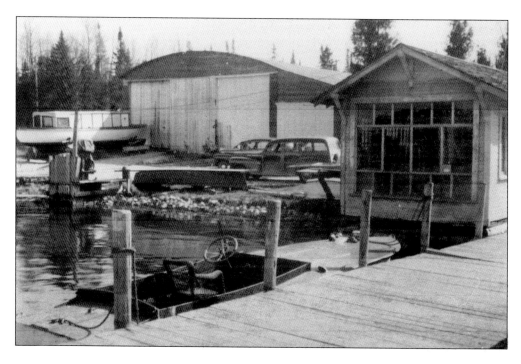

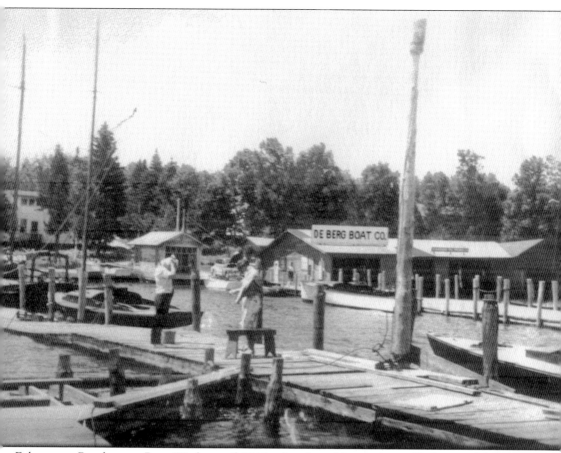

Folmer ran Rendezvous Boat Works until 1944, when he sold it to Amos Shoberg and John Demelick; they renamed the marina DeBerg. Their operation lasted for two years, and the business was sold in 1947, this time to George and Dee Honnila. They renamed the marina Viking Boat Harbor, and it is still called that today. In 1972, the railway was replaced with a travel lift, which modernized the boat-launching operation.

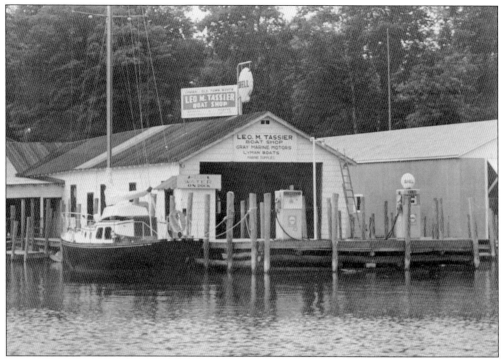

Leo Tassier started Tassier Boat Works in 1942. The business began with just one dock and a gas pump. Tassier's plan was a small-boat repair shop, but the business quickly grew with customers that followed him from his previous work at E.J. Mertaugh's Boat Works. Tassier repaired and built boats for customers. The expanding business required the addition of docks, storage space, and a workshop. Leo Tassier retired from the business in 1982, and it was taken over by his son and grandson.

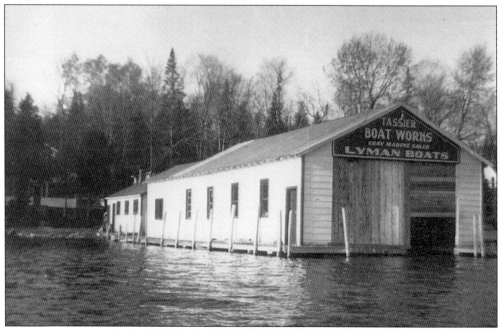

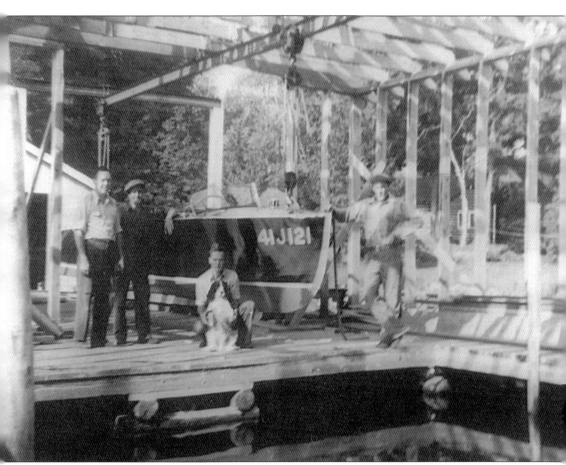

Launching and removing boats from the water is a steady business in the North, and Leo Tassier used a chain fall for this work. Launching wood boats is a bit more complicated, as they have to soak up water so they do not sink. Oftentimes, they are left on the chain fall to keep them afloat while they seal themselves.

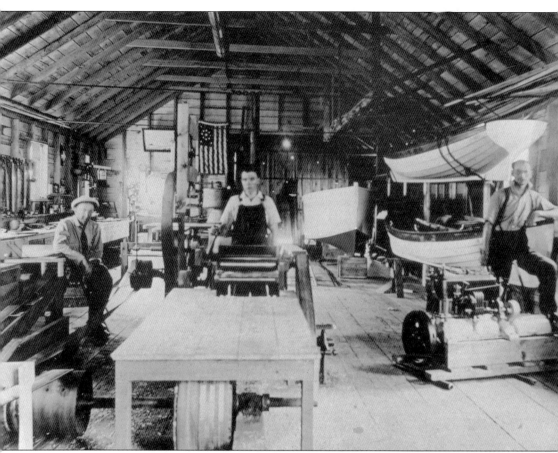

Cedarville Boat Works was opened in 1907 by Harrison and Robert Hamel. It was a full-service marina, and the brothers built boats until 1913, when Harrison left for the city to become a building contractor. One of their boats, constructed in 1910, is still shown at the Antique Wooden Boat Show each year.

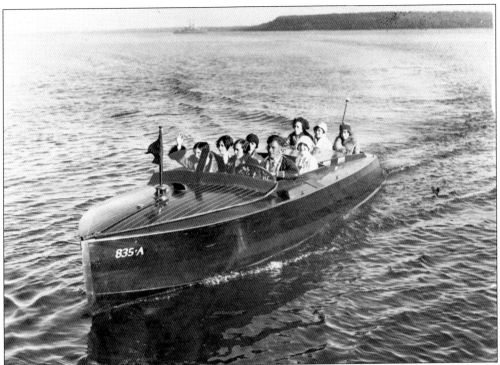

Once powerboats were introduced to the area, travel around the Les Cheneaux Islands and beyond became easier. In these two 1920s photographs, several people are aboard the Hacker-Craft *Letsgo* (above) and the Chris-Craft *Fleetwood* (below). Both boats are in the Mackinac passage with Mackinac Island behind them. They are headed toward the Les Cheneaux area.

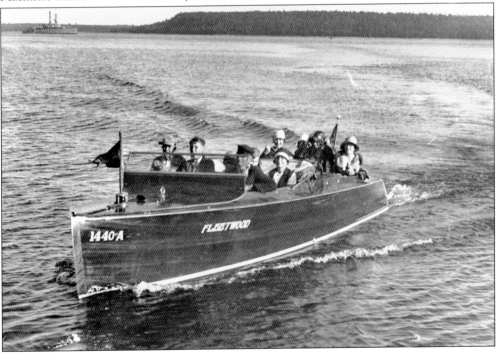

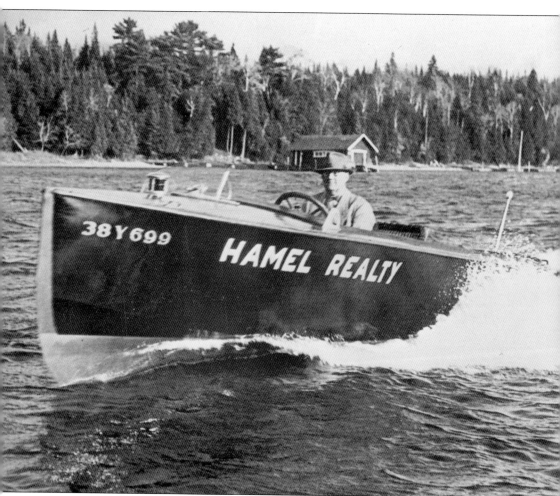

A common sight on the water was Guy Hamel. He was a local realtor who only traveled by boat, which gave him access to all the Les Cheneaux Islands as well as the towns of Hessel and Cedarville. It was the best way to take customers to view property. Hamel was also publisher of the local magazine *The Breezes*.

Cedarville Harbor was a busy place in the 1950s. Many small boats are tied to the docks. Outboard motors became very popular during the early 20th century, and by the 1950s most boats were equipped with a motor. This made commuting from the islands to the harbor towns faster.

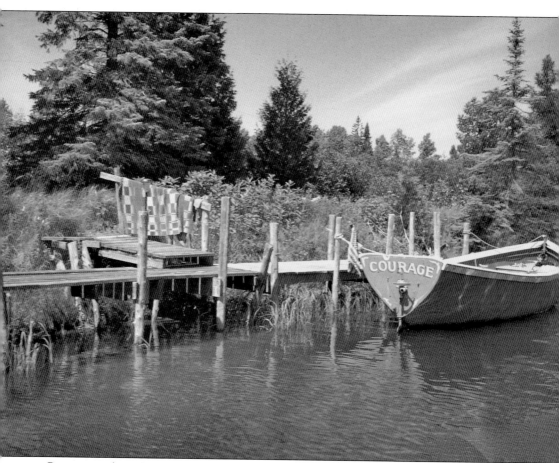

Courage is a launch that frequently travels the area waters. Her home is on Bosley's Channel. Launches are great boats for transporting supplies or people from one place to another. *Courage* serves that purpose well. (Author's collection.)

Six

ANTIQUE WOODEN BOAT SHOW

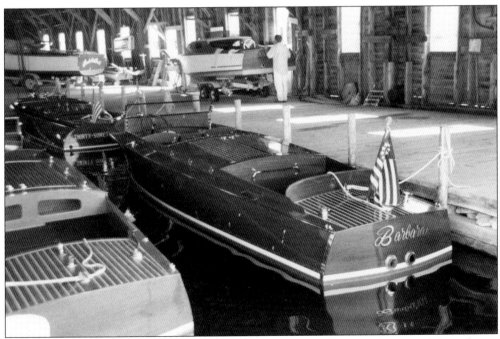

The Les Cheneaux Islands Antique Wooden Boat Show began on the second Saturday in August 1978. The public dock at Hessel and the E.J. Mertaugh docks became the grounds for the boat show.

Boats are on display in the boathouse that once stood at the E.J. Mertaugh's Boat Works. Spectators strolled through the boathouse and viewed the beautiful wood boats.

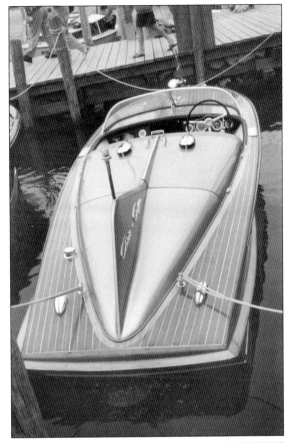

The Les Cheneaux Historical Association sponsors the boat show each year. The association has spent thousands of person-hours preparing and managing the show over the past 34 years. There are many categories of boats at the show, and the lone requirement across the board is each one has to be made of wood. The boats can range from this Chris-Craft Cobra (right) that was built in 1955 to this launch named *Sweetheart* (below). While the launch brings back memories of the early days in the Les Cheneaux area, the Cobra will catch the eye of any racing enthusiast.

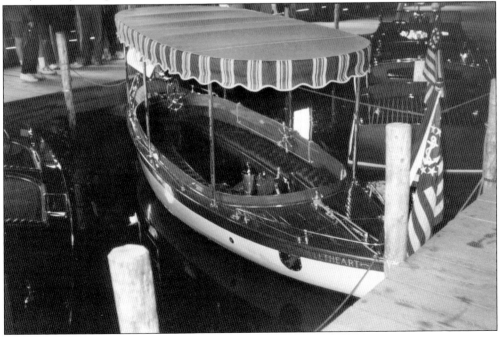

These triple cockpits are very common in Snows Channel. Triple cockpits have inboard motors that create a distinct rumble when the motor runs. Both of these boats have homeports at the Les Cheneaux Islands. While some are only launched for the show, many boats such as these are used through out the seasons by their owners to travel around the area.

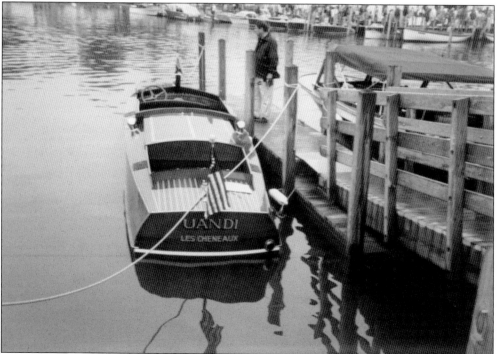

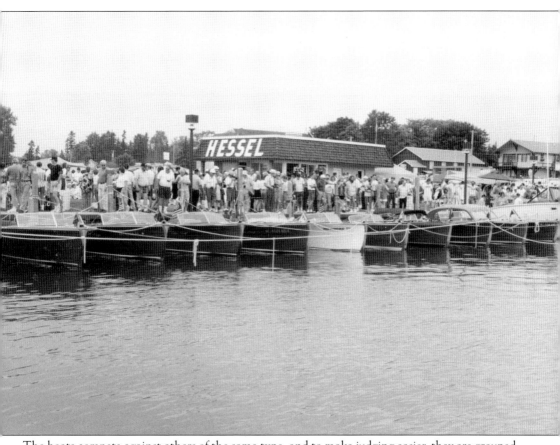

The boats compete against others of the same type, and to make judging easier, they are grouped together. There is a division for wooden sailboats as well at the show.

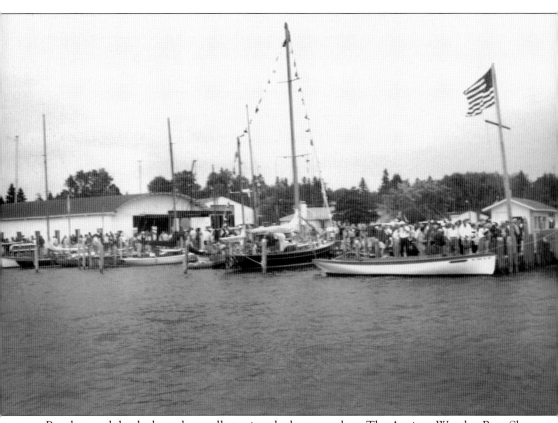

People crowd the docks and seawalls to view the boats up close. The Antique Wooden Boat Show draws thousands of visitors each year.

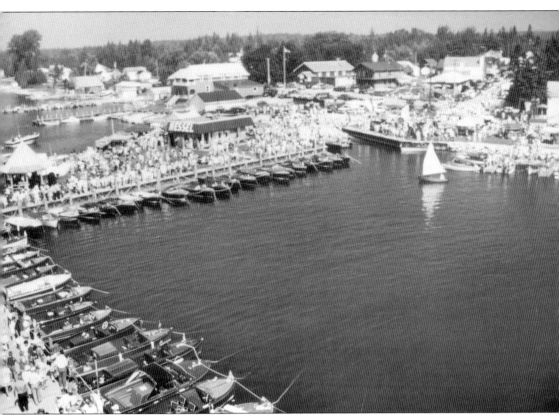

This aerial view of Hessel Harbor gives a dramatic view of the boat show. The crowds on the dock emphasize how popular the show is. People travel from the Lower Peninsula as well as neighboring states to witness the event, and competitors are both local and out-of-staters. The Antique Wooden Boat Show is a testament to the beauty and craftsmanship of wooden boats.

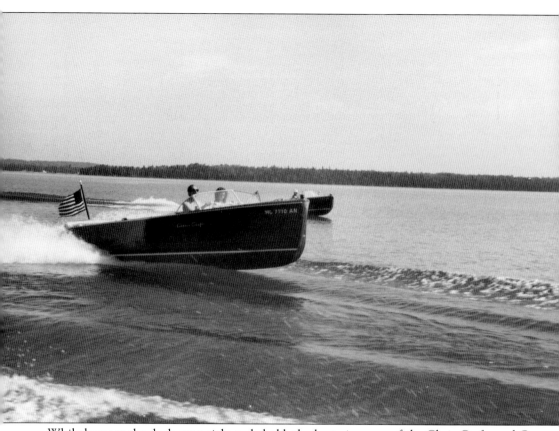

While boats at the dock are a sight to behold, the best views are of the Chris-Crafts and Gar Woods cruising the harbor. For those who stay to the show's end, it is pure joy to watch the wooden boats leave the harbor for their home docks.

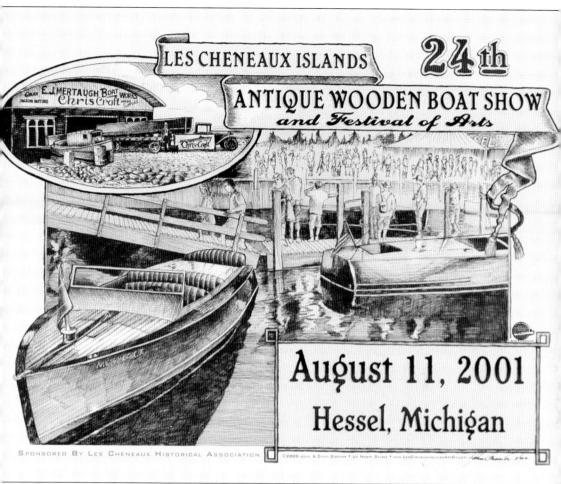

The Antique Wooden Boat Show also hosts an art show. Artists from all over come display their work. The Les Cheneaux Historical Association has a poster produced for each show. The past 10 posters were produced by local artists Diana J. and John Grenier. Their 2001 production depicts scenes of the boat show with an inset of the original E.J. Mertaugh's Boat Works. (Courtesy of Diana J. and John Grenier.)

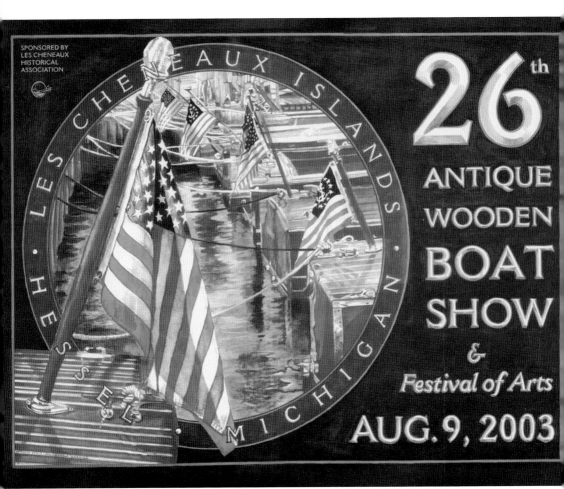

Diana and John Grenier's work in 2003 was for the 26th boat show. Their inspiration was the United States and American boats that fly the US ensign on the stern. This was the first year that multiple colors were used for the posters. This artwork can be purchased at the boat show or from Greniers' store. (Courtesy of Diana J. and John Grenier.)

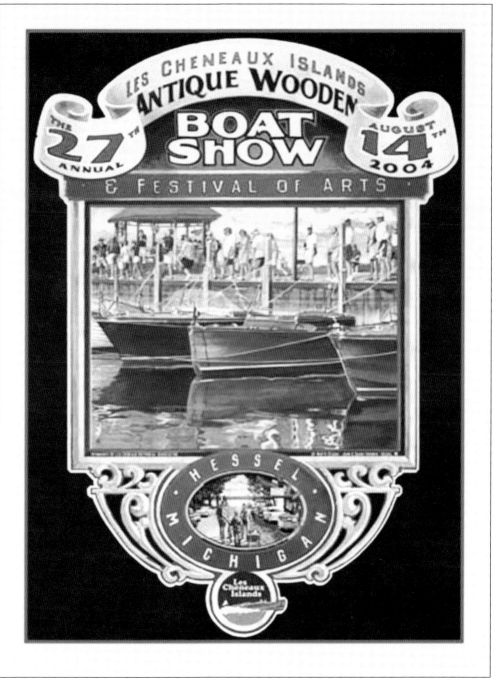

John Grenier is a sign painter. He letters many of the wooden boats in the area and creates signage for local businesses. The 2004 poster was inspired by hand-painted signs. It was done in the style of a carnival sign heralding the coming boat show. (Courtesy of Diana J. and John Grenier.)

28th Les Cheneaux Islands Antique Wooden Boat Show & Festival of Arts

BOAT SHOW
Les Cheneaux Islands

August 13, 2005 Hessel, Michigan

In 2005, Diana Grenier began creating the posters. This poster was based on a local boat named *Quiet Please*, which is often seen in Hessel Harbor. Diane painted this boat in liquid acrylic, as the previous two years were done. The original painting is on display in the Greniers' store. (Courtesy of Diana J. and John Grenier.)

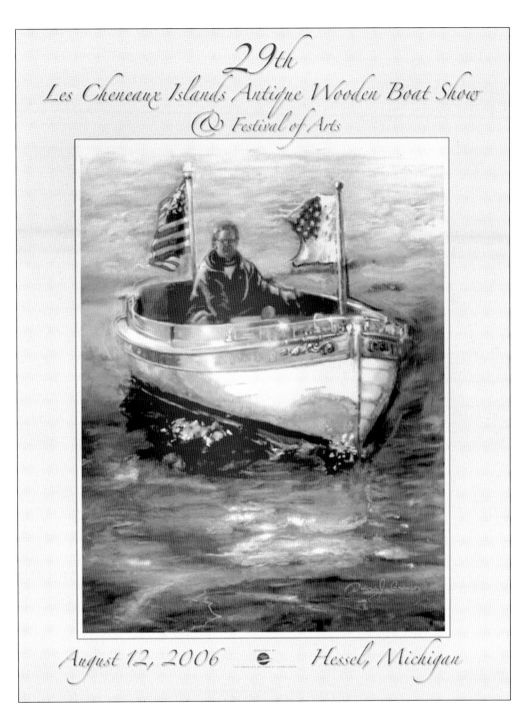

29th
Les Cheneaux Islands Antique Wooden Boat Show
& Festival of Arts

August 12, 2006 — *Hessel, Michigan*

Diana Grenier created a pastel for the 2006 Antique Wooden Boat Show. It featured Kip Horsburg's 1906 Truscott launch named *Antiki*. Ned Fenlon, a local businessman, celebrated his 100th birthday in 2006. The show featured a launch from Fenlon's birth year as a tribute to him. (Courtesy of Diana J. and John Grenier.)

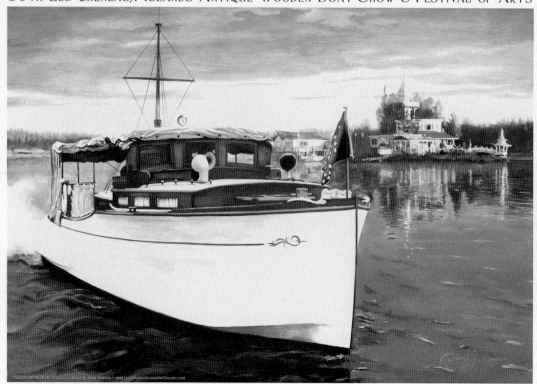

AUGUST 11, 2007 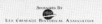 HESSEL, MICHIGAN

Diana Grenier based 2007's poster on the oil painting she did of Janet Carrington's cabin cruiser, *The Boss*. It is seen cruising Snows Channel past Dollar Island, a familiar landmark. The original painting is on display at the Greniers' store. (Courtesy of Diana J. and John Grenier.)

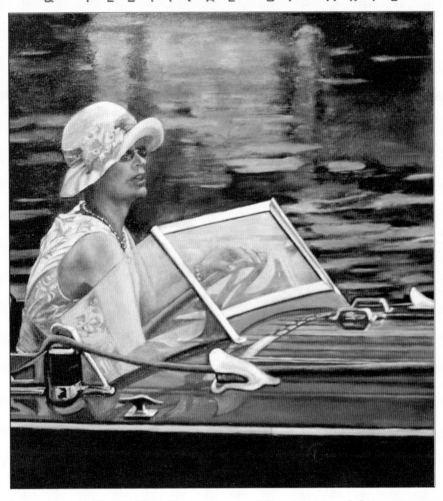

Diana featured Barb Taylor in the 2008 poster. It is based on a photograph of Taylor competing in a powder-puff race. She was driving Tom Flood's Hacker-Craft *Rendezvous*. The competitors dressed in 1930s attire for the race. (Courtesy of Diana J. and John Grenier.)

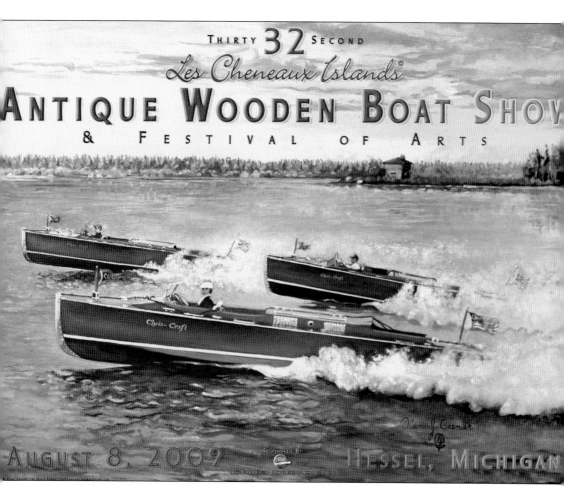

THIRTY **32** SECOND

Les Cheneaux Islands

ANTIQUE WOODEN BOAT SHOW

& FESTIVAL OF ARTS

AUGUST 8, 2009 • HESSEL, MICHIGAN

Diana believes that boats look best when they are moving on the water. In the 2009 poster, she featured the men's race with three Chris-Craft triple cockpits in Hessel Bay. The gentlemen are Nick Tobin in the foreground and Joe Reid in the lead boat. The original oil painting featured five boats in a dead heat. (Courtesy of Diana J. and John Grenier.)

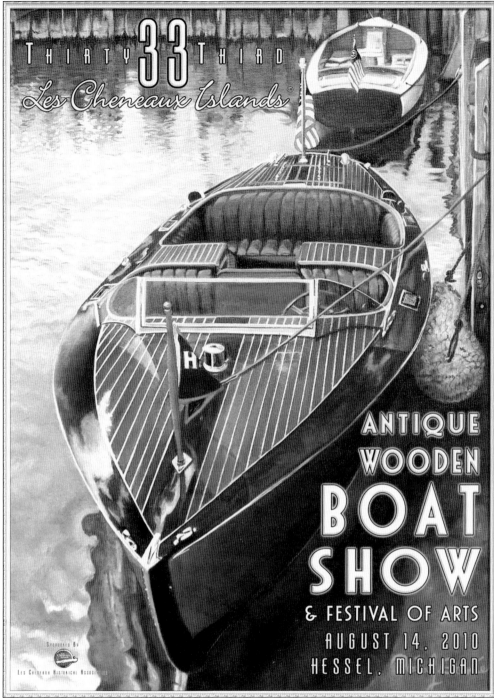

THIRTY **33** THIRD
Les Cheneaux Islands®

ANTIQUE
WOODEN
BOAT
SHOW
& FESTIVAL OF ARTS
AUGUST 14, 2010
HESSEL, MICHIGAN

In 2010, Diana featured a reproduction Hacker-Craft. The Antique Wooden Boat Show has a category for replica boats. Building specifications are available to the public to construct Hacker-Crafts. Here, the step-through to the back seat indicates that this boat on display at the boat show is a replica. (Courtesy of Diana J. and John Grenier.)

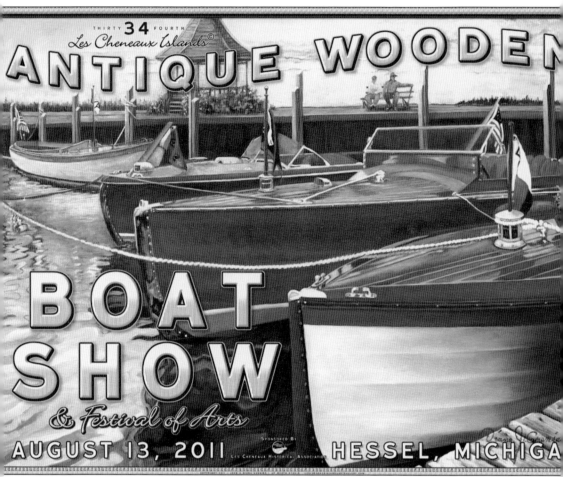

Diana gave a tip of the hat to Kramen boats for the 2011 poster. The launch named *My Bill* and owned by William Campbell is pictured with three Chris-Crafts. *My Bill* was made in 1917 in Hessel, Michigan, and was the featured boat for the 2011 Antique Wooden Boat Show. It has been in the Campbell family since 1952. (Courtesy of Diana J. and John Grenier.)

BIBLIOGRAPHY

McM Pittman, Phillip. *The Les Cheneaux Chronicles: Anatomy of a Community.* Charlevoix, MI: Les Cheneaux Ventures, Inc. by Peach Mountain Press, Ltd., 2002.

———. *Ripples from the Breezes: A Les Cheneaux Anthology.* Cedarville, MI: Les Cheneaux Ventures, Inc., 1988.

Melchers, Rose S. *Of Fifty Summers.* Cedarville, MI: Les Cheneaux Historical Association, 1999.

Shoberg, Helen C. *Early Hotels in the Les Cheneaux Islands.* Cedarville, MI: self-published, 2002.

DISCOVER THOUSANDS OF LOCAL HISTORY BOOKS FEATURING MILLIONS OF VINTAGE IMAGES

Arcadia Publishing, the leading local history publisher in the United States, is committed to making history accessible and meaningful through publishing books that celebrate and preserve the heritage of America's people and places.

Find more books like this at
www.arcadiapublishing.com

Search for your hometown history, your old stomping grounds, and even your favorite sports team.